Shooting Yourself

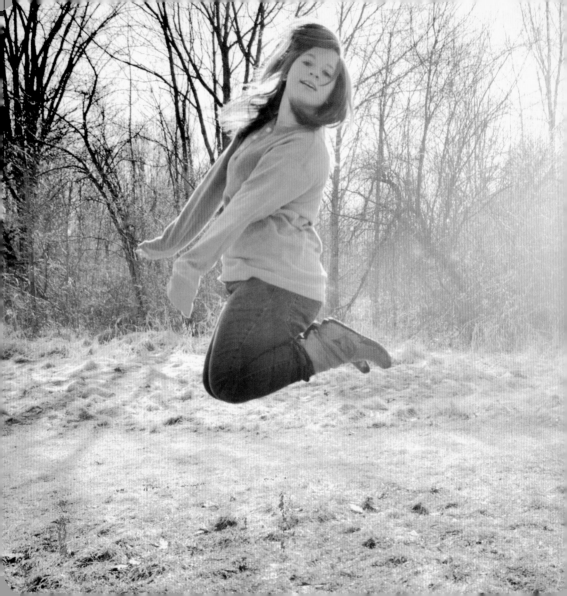

Haje Jan Kamps

Shooting Yourself

Self-Portraits with Attitude

ILEX

Quick contents

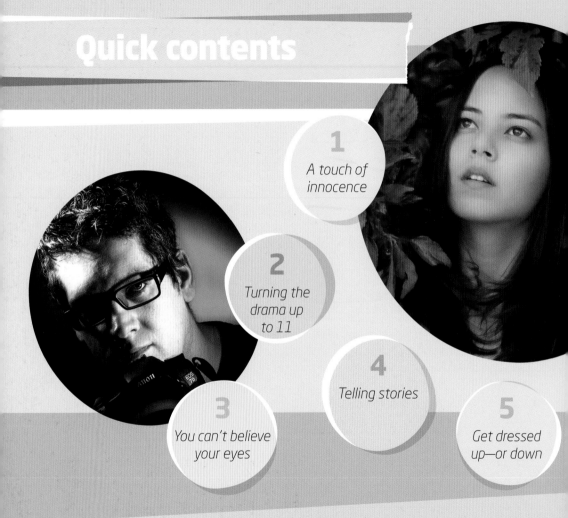

8
In action

7
On location

9
*Gadgets, props,
& things, oh my!*

10
*I'm seeing
double!*

6
Getting saucy

11
*Toy cameras
galore*

First published in the UK in 2013 by
ILEX
210 High Street
Lewes
East Sussex
BN7 2NS
www.ilex-press.com

Distributed worldwide (except North America) by
Thames & Hudson Ltd., 181A High Holborn, London
WC1V 7QX, United Kingdom

Publisher: **Alastair Campbell**
Associate Publisher: **Adam Juniper**
Managing Editor: **Natalia Price-Cabrera**
Specialist Editor: **Frank Gallaugher**
Editor: **Tara Gallagher**
Editorial Assistant: **Rachel Silverlight**
Creative Director: **James Hollywell**
Senior Designer: **Ginny Zeal**
Designer: **Lisa McCormick**
Colour Origination: **Ivy Press Reprographics**

British Library Cataloguing-in-Publication Data
A catalogue record for this book is available from
the British Library.

ISBN: 978-1-78157-994-7

Printed and bound in China.
10 9 8 7 6 5 4 3 2 1

Table of Contents

Chapter 5 - Get dressed up—or down 74

Make a bit of effort with period costumes or just the fanciest outfit you have in the closet.

Chapter 6 - Getting saucy 90

This chapter is all about sexy. If you've ever wanted to have a go at nude portraiture but weren't sure where to begin, start here. And the best bit? You don't even have to get naked!

Chapter 7 - On location 102

Most self-portraits are taken in a bedroom/living room. This chapter highlights the people who stand out from the crowd by taking it outside—or inside, for that matter.

Chapter 8 - In action 114

Did you know that sharks die if they stop moving? I know a few people like that, too. Self-portraits aren't limited to photos of people standing still, and here's the best of the movers and shakers, including those who run away from their cameras!

Chapter 9 - Gadgets, props, & things, oh my! 126

You didn't think this was going to be all about people, did you? Of course not—people have been posing with props since some clever person invented the paint brush. This chapter takes some of the most eye-catching props and displays them.

Chapter 10 - I'm seeing double! 138

If you haven't got a twin, don't despair—there are plenty of people who have armed themselves with digital editing in order to make themselves a mirror-sibling. This chapter shows off the best of the best, and shows you how.

Chapter 11 - Toy cameras galore 148

Whether it's a Lomo, a Holga, or an Olympus Trip with ancient film loaded, it's all about delicious lo-fi photos. It doesn't matter if you're doing it for real or faking it—it's the final result that matters!

Introduction

When I first started to explore photography, I realized that it was going to take me on an exciting journey of discovery. Not only was I learning things about physics, mechanics, and optics that I had never even thought about before, but I was also starting to see the world in a completely different way.

When you start seeing the world differently, you also start seeing yourself in a new way. I think this is why self-portraiture is such an incredibly exciting genre.

I've often noted that if photography is the art of seeing, then self-portraiture is the art of seeing yourself. I hope that this book can help guide and inspire you in the right direction.

Good luck!

Your faithful author with a sketchy-
looking mustache and a ukulele
he doesn't know how to play.

A touch of innocence

Self-portraiture is a magical world where truth and fantasy meet. There is something inherently true about the expression "the camera never lies," and yet you only have to pick up a fashion magazine to appreciate quite how much a photograph can, indeed, distort the truth.

The image you project in your self-portraiture is entirely one of your own design. This can sound a little scary—or it could be an opportunity to embrace!

When we point the camera at ourselves, we have the same scope to stretch and distort the truth. We choose what facial expressions to adopt, our clothes, and the environment we're photographed in. It's one of my favorite reasons for relishing self-portraiture—you get to be an actor in your own one-person production!

Keep Practicing

Turn on your television to a random channel and see if you can determine the general mood you are presented with. Are the people on the screen angry? Scared? Excited? Serious? Take a self-portrait that reflects their mood—and don't give up until you succeed!

You can express many powerful emotions using self-portraiture. When you're photographing yourself, it's an extra bonus that the model never gets bored before the photographer does!
Photo by Bryce Fields

With a little help from your friends

Photography is a curious medium; it can capture a specific moment in time, so there is an expectation that the camera never lies and only records the truth. While that theory of photography should be true for photojournalists or police officers who have the grizzly task of recording scenes of crimes and gathering evidence, it isn't always the case for everyone taking pictures.

There's a whole other side to photography: the creative, artistic one that isn't so much a re-creation of a slice of reality, but is a representation of the photographer's vision. As you are reading this book I am going to take it that this is what you are after.

When you take a photograph, you're re-creating–or even constructing–an image in the way that you see the scene and want the final product to look. A photograph is your interpretation of what you can see, and as we all see things differently, it's pretty hard to say that you're right or wrong.

Some photos are easy to get with a Self-Timer. For others, it's better to ask a friend for help.
Photo by Lucy Tindall
(Lucy Tindall Photography)

If you can envisage a photograph of a busy market scene, full of people and color and animation, you might be drawn to the interaction between two people in the foreground, while I on the other hand am more focused on the interplay of the different colors of the goods for sale. Neither interpretation is wrong; they're different, and they're the product of the different way that we all see things.

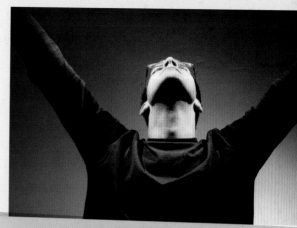

Getting the lighting and focus right in this photo was an exercise in frustration until I asked a friend to check the focus and press the button for me. It's still very much a self-portrait, however!

In short, any photo you take is a representation of your vision, and your camera is the tool that you use to realize this vision. If you're using your camera properly and you're making the correct technical decisions, then a photograph should represent a scene exactly how you want to interpret it. You can draw attention to some elements and detract from others. You can make an image feel dream-like and whimsical, or bold and punchy. You can choose the story that you want to tell through the medium of photography.

This idea that a photograph is a representation of your vision is fundamental to the craft of photography. It would be a very boring world if none of us ever saw the world around us differently. The key factor is that you control your camera and use it to express your vision. You call the shots, quite literally.

All of this means that if you need help to achieve your photographic goals, that's perfectly okay, especially when it comes to self-portraiture. Sometimes we can't achieve precisely what we want without a little assistance. You might know just how you want the scene to appear: you being soaked by an exploding water balloon in your shower. You know that the frame will need to be oriented vertically to accommodate you and enough background to give it context, you know just the degree of depth of field that will draw the viewer's eye to the point of focus (but blur out the hideous 1970s tiles in the background), you know that you'll need a fast shutter speed to capture the balloon bursting, and you've set up your flashes to help freeze the action. Then you realize that you have a slight problem. There's no way that you can set up the shot, press the shutter release button, run around into the shower, pick up your water balloon, get into position, and burst the balloon in time for your camera to be sure of capturing it. It isn't the sort of photo that you can keep on trying until you get it right—once you're wet, you're wet! The solution is to ask someone to press the button for you.

If it bothers you that someone else is responsible for pressing the shutter release button, think of it this way: Photographers are always using tools in their photography—you probably own a tripod and a remote trigger, for example. Is that cheating? Of course not.

When you're asking someone else

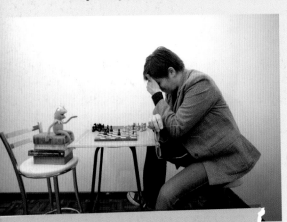

90 percent of a self-portrait is having the idea for the concept you want to illustrate.
Photo by Elis Alves (Elis Alves Photography)

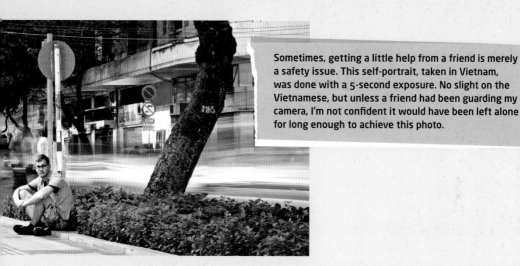

Sometimes, getting a little help from a friend is merely a safety issue. This self-portrait, taken in Vietnam, was done with a 5-second exposure. No slight on the Vietnamese, but unless a friend had been guarding my camera, I'm not confident it would have been left alone for long enough to achieve this photo.

to take your self-portraits for you, you're not cheating anybody. If it's your vision that is being photographed, you are the photographer; if you're taking a photo of yourself, it's a self-portrait. If it helps, it's probably pretty safe to think of the other person as a human tripod-and-remote release, rather than another person.

If you set up the shot and realize your vision by selecting the camera angle and choice of lens, choosing the aperture, shutter speed, and ISO value, and then finishing it off in post-production, it's your photograph. If someone happened to release the shutter for you because the ten-second delay on the Self-Timer was insufficient to let you scramble up the tree before the sensor was exposed, or in our earlier example, burst a water balloon in the shower, it doesn't make it any less your photograph. Your friend had the easy part in making it all happen, because what happened was entirely your creation. Getting a little help from your friends? Of course you can!

Introducing...

Callan Kapush

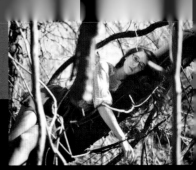

Rest

Callan has an almost impossibly playful and innocent style of photography, and as I was doing the research for this book, I kept stumbling across her self-portraits. To find out what makes her tick, I decided to interview Callan.

A sophomore in college, 19-year-old Callan Kapush is a keen photographer who refuses to let herself be characterized within a single genre. Her interest in photography was kick-started by her love of music. "I loved live-music photography. I would always bring my little Kodak point-and-shoot camera to shows and snap away every second I could," she says.

Callan saw self-portraiture as a way to express herself, and to "crack open her shell." "I wanted to branch away from taking pictures of my twin sister, which I was getting so comfortable doing.

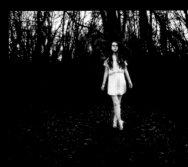

Rebirth

"Sometimes I want to tell a story projecting a different persona, but still have it relate to my life experiences and my emotions. In my photo, *Rebirth*, for example, I wanted to portray the inner being and thoughts inside of me," she says. "I wanted to show the story of the chaos in my head, having me portray my good thoughts and the forest symbolizing my bad thoughts.

"My photo, *Soft Spoken*, can tell the story of love once lost for someone, but to me it shows the story of a personal freeing cleanse of all the guilt in my life. I would love to get into portraying more and more different characters in my photos,

Underneath

Resolution

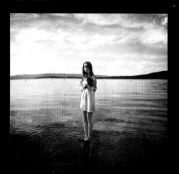

Soft spoken

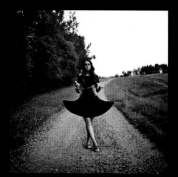

The choice

but for now it is a way of expressing myself and showing my personality."

Of course, not all self-portraiture happens in a vacuum, and Callan has quite a few interesting stories to tell about times where the rest of the world intersected with her art. "I always laugh at myself for how ridiculous I must look to some people when they see me press the shutter and sprint into position trying to beat the timer," she laughs.

"Other photographers probably inspire me most," Callan muses, and passes the torch by offering some advice of her own: "Never stop taking pictures! Photography is like an instrument; if you never practice it you will never get better."

One piece of advice she also offers rings true both with my own experiences and seemed to be reflected in many of the other photographers' interviews I did for this book—don't be scared. "I know I was terrified to share my first self-portraits with just my close friends. I never thought I would have the confidence to share them with all of Flickr and Facebook!

"Self-portraits are very fulfilling to me because I take them for me. I can go crazy on editing or do odd poses, because to me, it's right. Self-portraiture keeps me sane in my times of stress. It is a form of therapy for me," she concludes.

*All photographs by Callan Kapush

There's more here than meets the eye

A successful self-portrait engages on a surface, aethetic level, but also reveals a deeper level of personality and character. Check out these photographers, both in style and in content—you'll feel like you know them already!

Natalie Vaughan

IMAGE	Yellow Blossom
AGE	23
LOCATION	Arcata, California, USA
WEBSITE	natvonphoto.com

SHOOT NOTES / MINI BIO

"I like being the subject of my photography because I get to make the picture exactly how I want it."

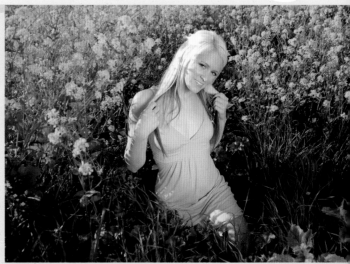

© NatVon Photography

Naomi Hipps

IMAGE **Exposed**
AGE **18**
LOCATION **Prestwich, UK**
WEBSITE flickr.com/photos/naomihipps

SHOOT NOTES / MINI BIO

"You can experiment so much more with self-portraits. You have no time constraints, no one will judge you if you want to try something a bit off the wall, and if something doesn't work you can just keep trying. This photo was taken when I was experimenting with my brand new flashgun. When I first turned it on the flash was particularly strong and everything about how my flash and camera were set up was wrong. When I tested it to see if it was working, I liked the blown-out effect it created, so I grabbed my tripod and turned the camera on myself. I played around with my exposure and settings until I ended up with this shot. I love how my skin is blown out but the detail in my eyes and lips is still so strong."

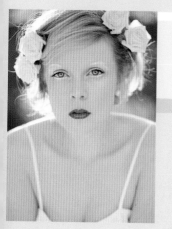

Elly Lucas

IMAGE **Ice**
AGE **22**
LOCATION **Sheffield, UK**
@ellylucas
WEBSITE ellylucas.co.uk

SHOOT NOTES / MINI BIO

"I guess I've always really enjoyed the challenge of self-portraiture: finding clever ways of setting up in your chosen location, thinking constantly about your positioning, where the focus point's aiming, the styling, how to make it interesting and—most importantly—how to move on the other side of the lens. I think a knowledge of how to pose yourself provides you with much greater empathy when working with portrait subjects."

Carly Wong

IMAGE **Hide Me**
AGE **30**
LOCATION **Bristol, UK**
🅑 @squidzero
WEBSITE Squidzero.com

SHOOT NOTES/MINI BIO

"It's no secret that I love snow—perhaps in part because to me it's always signaled a departure from real life and responsibilities. When it snowed as a child, school was canceled, and when it snowed as an adult a couple of years ago the building I worked in started to crumble due to subzero conditions taking a toll on our poorly maintained masonry, hence a closed work place. Sad as that was for the organization, it was a real gift to me. Snow was something I'd always wanted to capture since becoming more serious about my photography, not to mention being able to go sledding for the first time in my life!

"Almost every time I'd taken a self-portrait prior to this it had been planned out and executed with almost military precision, according to that plan. This image was a real accomplishment in that respect because all I had done was head out with my camera, tripod, a small white dress and pair of fluffy boots—it was cold! I wanted to create a sense of freedom, happiness, and ironically a feeling of warmth in the photo. I'm not sure whether I achieved any of the above, but I like the photo regardless."

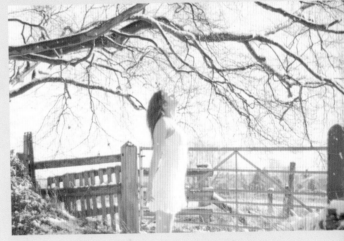

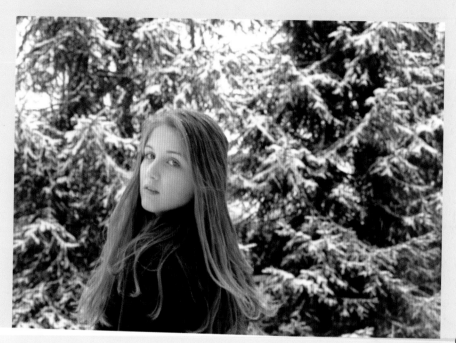

Emme Harris

IMAGE Winter Wonderland
AGE 24
LOCATION Summit, New Jersey, USA

SHOOT NOTES / MINI BIO

"I took this photograph in my backyard right after a big snowstorm. I wanted to capture the beautiful snowy trees and the essence of the winter wonderland before me. Just looking at the picture makes me want to get a mug full of hot chocolate and watch holiday films!"

There's more here than meets the eye

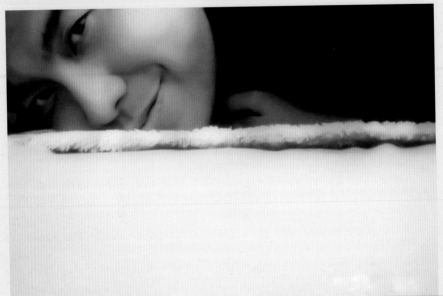

Wallei Bautista
Trinidad

IMAGE **Untitled**
AGE **34**
LOCATION **Ajman, United Arab Emirates**
📧 @wallei
WEBSITE facebook.com/walitografia

SHOOT NOTES / MINI BIO

Wallei is a Middle East-based footwear specialist and photography enthusiast, blogger, poet and artist whose passion for taking self-portraits gave him a different kind of fulfilment. For him, self-portraiture is therapeutic and thought-provoking and provides a sense of self-upliftment.

"Self-portraits are all about discovering who you truly are. Not only being able to see yourself the way your friends and loved ones do, but to see the inner person in you so intimately. It takes courage to practice this, but it's been so helpful to me on my journey."

Danielle Pearce

IMAGE Beauty
AGE 18
LOCATION Virginia Beach, Virginia, USA
🅣 @_DaniellePearce
WEBSITE daniellepearcephotography.com

SHOOT NOTES/MINI BIO

"At the age of 14, I started to get into photography. I wanted to take pictures of people, however, I did not have any models that would work with me because I was such a beginner. That is why I turned to self-portraits.

"This photo was taken on my kitchen floor. I had to create a tripod because mine wouldn't position itself to point the camera straight down. I used two chairs and a piece of wood with a hole in it to create a stand for my camera. In this photo I was going for something elegant. I wanted a shot with my hair spread out everywhere. I ended up choosing this one out of over a hundred because of the direction I was looking. I loved the look on my face and it was perfect for the shot."

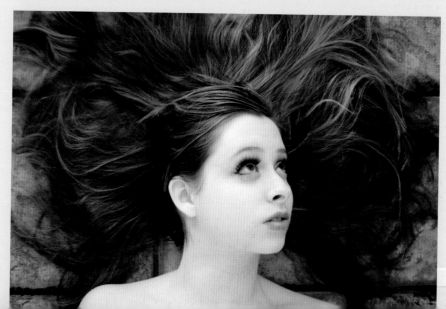

Andréia Takeuchi

IMAGE Alive as Red
AGE 22
LOCATION São José, Brazil
WEBSITE andreiatakeuchi.com

SHOOT NOTES / MINI BIO

"I first started taking self-portraits as a means of expressing myself and learning how to use my camera. It became a habit and a need to keep developing since I didn't have access to models.

"When I took this picture I wanted to achieve the effect of being submersed in the color red. To me, the color red is so interesting because it can be connected to many different meanings depending on its use. It can mean death, sin, caution, desire. In this picture I wanted to show how red is a color full of life."

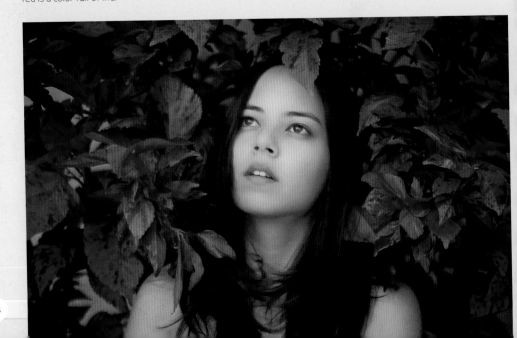

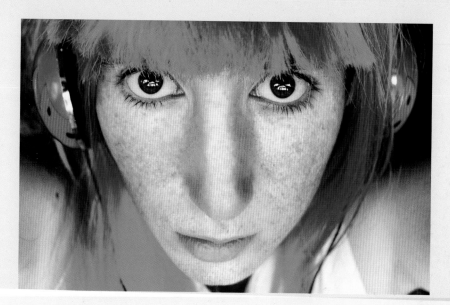

Gemma Bou

IMAGE	Deeply Inside
AGE	21
LOCATION	Valladolid, Spain

 @GemmaBou

SHOOT NOTES / MINI BIO

"I started taking self-portraits because my friends and family didn't like to be photographed. When I bought my first reflex camera I had to practice with someone, so who better than me? Also I like self-portraiture because it's the best way to express what I want to express through a photo. I know perfectly what I want to transmit and how the expressions of my face and body have to be.

"With this photo I tried to transmit the feeling of a song that I had just heard. The song talks about how a person can get deeply inside you and you really don't know why. The photo was taken in the kitchen of my house; there's a big window and lots of light."

Turning the drama up to 11

Can you take a wild guess at what the most powerful tool you have available as a photographer might be? Your camera is sort of crucial, of course, and without your creative ideas you'd be nowhere, but a lot of new photographers somehow overlook the most elemental part of photography: light.

It should come as no surprise that light is important; you can't take photos in complete darkness. If there was even the slightest shred worth of doubt, the origins of the word "photography" come from the Greek for "drawing with light."

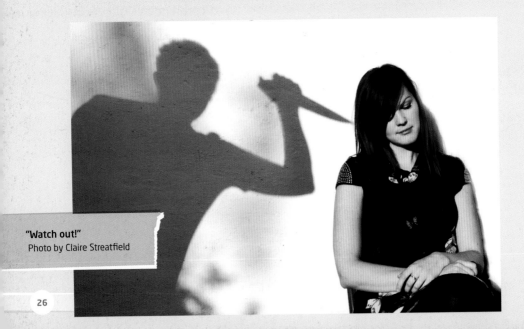

"Watch out!"
Photo by Claire Streatfield

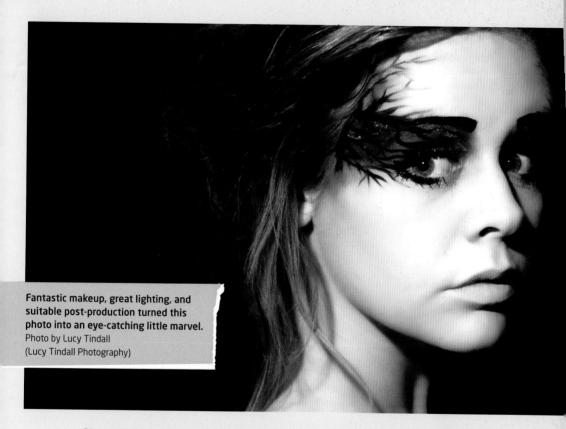

Fantastic makeup, great lighting, and suitable post-production turned this photo into an eye-catching little marvel.
Photo by Lucy Tindall
(Lucy Tindall Photography)

Photography is all about light: directing, creating, blocking out, and manipulating light. Your lens focuses light. Your imaging sensor captures light. And, if you want to be a truly magnificent photographer, you had best make light your close friend rather quickly.

Turn down the lights, turn up the drama

Pay close attention to the moods and lighting in movies. In this case, the lighting is "natural" (only the lighting available in the scene), but it works well to build the mood.
Photo by Lauralyn Brickhouse Wilkins

You can capture fantastic photos in bright sunlight, but if you want to take full control, you're going to have to take a different approach. Any room that you can make reasonably dark is perfect. It doesn't have to be airtight, but the lights you use have to overpower all the other light. The key is "relative brightness," and you can do a lot of fun things with simple lighting setups.

In my early days of photography, before I got into studio- and flash-based photography, I used huge halogen spots (also called shop lights, work lamps, or similar). They generally come in 500- or 750-watts, and if you go to your local hardware store, you'll find that they are a heck of a lot cheaper than studio lights. Of course, the color temperature on them is completely out of whack, but if you're just starting out and wanting to experiment with artificially-lit photography, it's not a bad place to begin.

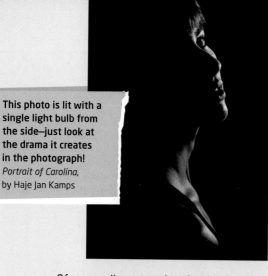

This photo is lit with a single light bulb from the side—just look at the drama it creates in the photograph!
Portrait of Carolina, by Haje Jan Kamps

A lot of photography books drone on about "top lighting," "front lighting," "side lighting," "three-point lighting," etc. What I've realized recently is that all of this theoretical stuff is moot. With a little bit of common sense, you can deduce simple lighting situations from the photos you look at. If someone has light on the right side of their face, that's probably where the light is coming from.

Of course, I'm not saying that books aren't useful for learning, but I'm a strong believer in "learning by doing." Self-portraiture gives you a luxury that no other form of photography affords: all the time in the world. So, set up a couple of shop lights and sit in front of a mirror. Move the lights around, and see what happens to the light. Once you've found a setting you like, replace the mirror with a camera.

This photo was taken with a very simple technique: using strong side lighting, and carefully ensuring the light didn't hit the wall behind the model. The light-and-dark contrast makes this an extremely eye-catching photo.
Portrait of Meke Kamps by Haje Jan Kamps

Getting the exposure right

The one gotcha when it comes to working with dramatic lighting is that it can confuse the hell out of the light meter on your camera. When it sees a mostly dark setting, the camera thinks, "oh dear, I need to use a longer exposure to make up for all this darkness." Usually, that's correct, but in this particular instance, because we're going for finely crafted lighting, it means that you are probably going to be overexposed.

The trick is to expose for the highlights. If you've never taken your camera off automatic mode, that might sound a little bit scary, but it's not, honest. Do a quick Google search for "How exposure works," and read up on how shutter speed, aperture, and ISO work together to create a good exposure. Now you'll be able to set your camera to fully manual, and dial in an exposure. Simply use trial and error to get your exposure right by taking a photo and carefully checking it on the LCD screen. You want to go as bright as you can on your highlights without burning them out. Different camera models have different ways of helping you out when it comes to analyzing the exposure of the images you've taken, so check your manual!

It's perfectly possible to shoot with artificial light outside during the day, but it means you need quite a lot of flash output to ensure the flashes are brighter than the ambient light.
Portrait of Absynthia Valentine by Haje Jan Kamps

Histograms

When working in manual exposure, your histogram view is your best friend. Check out your camera's manual or Google "How to use a histogram on a camera" to learn how to use it. Once you've wrapped your brain around histograms, you'll wonder how you ever made do without them.

As an exercise, try looking at the photos in this chapter and analyze where the lighting might be coming from. Once you start to get the hang of it, you're ready to graduate. I always find that taking a closer look at photos around me—in magazines, on Flickr, etc.—helps me become better at "thinking like a photographer." Best of all, it helps you become a better photographer when you're not even holding a camera. How nifty is that?

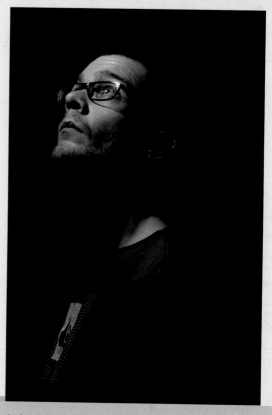

A simple halogen spot pointing down from above turned out to give slightly too harsh a light, so I decided to add a photographic umbrella between the spotlight and myself (it is just out of frame in this photo) for a softer light and a much better result.

I couldn't embark on a project quite as narcissistic as writing a book about self-portraiture without including a little bit of an introduction to myself. Hi, I am your friendly author. I started taking photos with my father's Canon A-1, and quickly discovered that taking photos was fun, but experimenting in the darkroom was a lot more interesting. At the time, I figured that you only got one shot at taking a photograph. In the darkroom, however, you get a lot of attempts at getting your photography right. You can spend hours and hours on a single frame, printing it again and again on different contrast papers with darkroom manipulations (like dodging and burning—technique names that will be familiar to people who are using Photoshop or similar), and by experimenting with different exposures, crops, and treatments of photographic prints.

When I was living in Norway, I bought my first digital camera around 1998. At the time, there wasn't much of a Norwegian scene for writing about photography, so I decided to start my own photography blog about digital cameras in Norwegian. From there on, the rest is history. My blog evolved into one of the most popular digital photography websites in Norway, and I eventually handed over the editor position to a colleague.

Self-portrait with sunglasses

Minimalist self-portrait

Turning the drama up to 11

Self-portrait with quail egg

Equipment used

For many years, I've been shooting with Canon's entry-level cameras (I've owned a D30, D60, 300D, 350D, 400D, 500D, and 550D), but I've recently retaken the plunge into the wonderful world of full-frame photography with a rather tasty Canon EOS 5D MK III. My most frequently used lenses are my Canon 50mm f/1.4, my Canon 100mm f/2.8 Macro, and my trusty Sigma 70–200mm f/2.8.

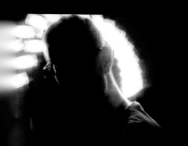

Self-portrait with strobscopic flash

Self-portrait with bunny

Of course, I didn't stop writing about photography, and I spent the next 15 years blogging for a large number of sites, writing for magazines, working as a journalist, and writing a number of books. These days, as my day job, I run Triggertrap (Triggertrap. com), a company that creates camera triggers for iPhone, Android, and Arduino.

I realized pretty quickly that writing about photography meant that I needed to experiment with a lot of different types of photography, and I rarely found models who were patient enough to deal with all the mistakes and experimentation I was going through. I ended up doing a lot of self-portraiture, less with the goal of showing myself off, and more to learn about photography. A side effect of taking a lot of self-portraits turned out to be that, perhaps mostly due to the sheer number of photos I was taking of myself, some of them actually came out rather well.

My photography is inspired almost exclusively by the photos that come through via my Flickr feed. It never ceases to surprise me how much incredible talent is out there, and the quality of the photos people are sharing with the world. It's humbling and deeply inspirational to me.

* All photographs by Haje Jan Kamps

Hollywood can't hold a candle to these guys

When you think "lighting setup," you probably think of a professional photo studio, or perhaps Hollywood. The photos featured here will hopefully inspire you to give it a go yourself—trust me when I say it'll make your photos a lot better!

Jose Antonio Moreno

IMAGE **My Shadow**
AGE **41**
LOCATION **Caguas, Puerto Rico, USA**
🅣 **@JoseMoreno_fm**
WEBSITE fotografiamoreno.com

SHOOT NOTES / MINI BIO

"I took this picture 20 minutes after my grandmother died. I went outside and I saw a strong glow from the sky created by the sun's rays. When I looked down, I saw my own silhouette, so sharp, so perfect...I grabbed my phone and took this picture to freeze the day, the moment, this very second of my life. With it, I can say thank you to my grandma for all her attention and love."

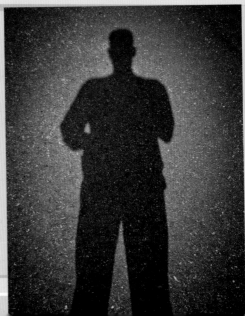

Sodanie Chea

IMAGE **Untitled**
AGE **24**
LOCATION **Norwalk, California, USA**

 @sodaniechea
flickr.com/sodaniechea

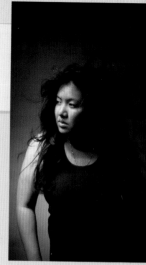

SHOOT NOTES/MINI BIO

"I started with self-portraiture because I don't have many photos of myself out in the world. However, along the way I started to work on all sorts of lighting techniques and broadened my creativity. From doing self-portraits, I've noticed a significant improvement when I shoot models."

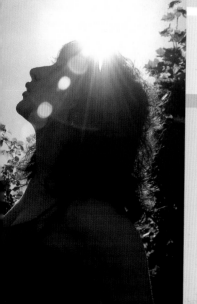

Naomi Hipps

IMAGE **Glare**
AGE **18**
LOCATION **Prestwich, UK**

flickr.com/
naomihipps

SHOOT NOTES/MINI BIO

"This was taken in my garden. I love breaking the rules of photography and purposefully shot this against the sun to get the magnificent glare above my head. I love how the sun gives me a glowing outline bringing out even the tiniest details such as the hairs on my arm. The flowers create an upward climb and everything about the shot seems to want to float up. The difficulty was getting the glare nicely placed without turning myself into a silhouette."

Richard Sparey

IMAGE **Untitled**
AGE **32**
LOCATION **Congleton, UK**
@rsparey
WEBSITE richardsparey.com

SHOOT NOTES / MINI BIO

"In creating a portrait you are showing how you as a photographer see the sitter. When a client buys a photographer's image they are not just buying an image of themselves. They are buying the photographer's perception of them. I approach a self-portrait with the same thought process, 'How do I view myself?'"

Ivan Villa

IMAGE **Apocalyptic**
AGE **23**
LOCATION **Sacramento, California, USA**
WEBSITE ivanvilla.com

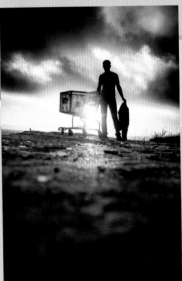

SHOOT NOTES / MINI BIO

You don't have to be an expert to see where this light source is coming form, but by golly is it effective!

Krisztian Sipos

IMAGE As a Drummer • Never Smoked • Standing Out
AGE 37
LOCATION London, UK
 @photoshippy
WEBSITE photoshippy.com

SHOOT NOTES / MINI BIO

"Self-portraiture is fun to do. Who doesn't like fun? It's another creative field where you can go wild. I always have some concept in my mind that I want to achieve using strobes or natural light. I can be as creative as I want; there is no limit."

As a Drummer

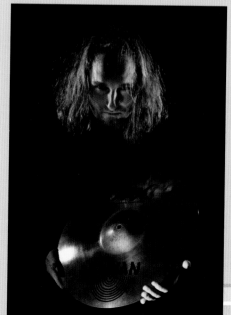

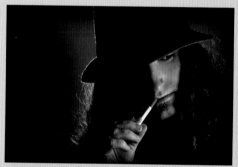

Never Smoked

Standing Out

Rosa Gonzalez

IMAGE **Free**
AGE **28**
LOCATION **Canton, Georgia, USA**
@rosacreative
WEBSITE rosacreative.com

SHOOT NOTES/MINI BIO

"Self-portraiture is something that I've been doing for fun or when I need a creative break from a web project. It all started when I purchased my first DSLR. I really wanted to sharpen my picture-taking and editing skills, so what better and more accessible subject than myself?

"This image is one I like to call a 'happy accident.' The light coming through the window in my room was lovely, and I wanted to capture some movement with my hair. So I did what any self-portrait artist would do while no one's watching: flipped my hair back and forth over and over like a crazy person. And there it was. The one perfectly in-focus image. This image is inspiring and uplifting to me. It was shot during a time when I had freed myself of circumstances that were bringing me down. And that's exactly what this image makes me feel every time I look at it. Free."

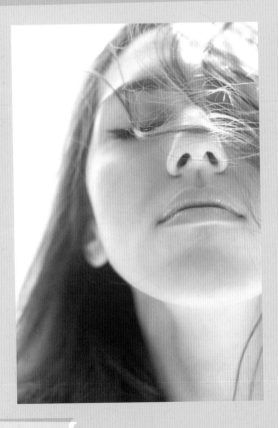

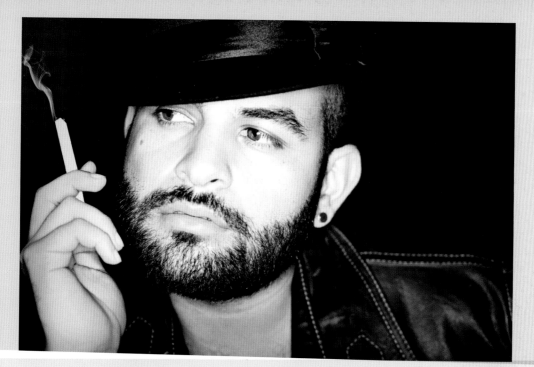

Gabriel D. Gastelum

IMAGE	**Smoke**
AGE	**29**
LOCATION	**Los Angeles, California, USA**
	@gabrielgastelum
WEBSITE	gdxphoto.com

SHOOT NOTES / MINI BIO

"This self-portrait has a very 'Tom of Finland' feel (all masculine, leathery, and beardy).
I do not smoke, so it was interesting to see how I held the cigarette—apparently, not correctly!

"The shot was mostly to test some new lighting I had purchased. But, it was fun to do nonetheless and I liked the end result."

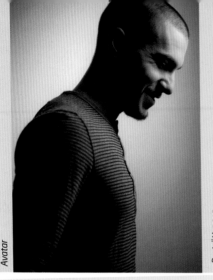

Avatar

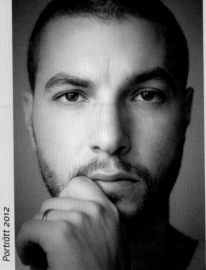

Porträtt 2012

Manuel Ek

IMAGE Avatar
Porträtt 2012
LOCATION Malmö, Sweden
WEBSITE manuelek.se

SHOOT NOTES / MINI BIO

"Since I shoot a lot of portraits in my work, I tend to do my own portraits as well when I need a new one, for example, for business cards or avatars for the internet.

"Getting everything right when shooting selfies can be hard. You have to prefocus and set everything up without anything in the frame, and then hope that it will turn out as you want it. I'm glad shoot digital, which means I can just throw away the ones I don't like."

Porträtt 2012: "I really like this one and this will probably be the selfie of the year. I shot it plain and simple with natural light from a window and the camera on a tripod. I triggered with a wired remote trigger and adjusted the focus as I went along, getting closer and closer to that perfect image. I struggled a bit with the pose, but eventually found one I really liked. I look serious but not angry and the image makes me happy!"

Marco Donazzan

IMAGE **Black • Tazza**
AGE **26**
LOCATION **Torri di Quartesolo, Italy**
WEBSITE marcodonazzan.com

SHOOT NOTES / MINI BIO

"I don't like to be photographed by other people, so if I want pictures of myself, I have to take them myself!"

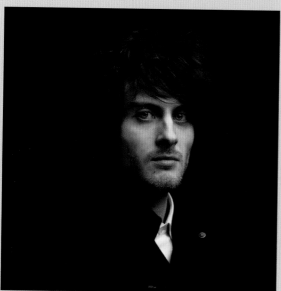

Black

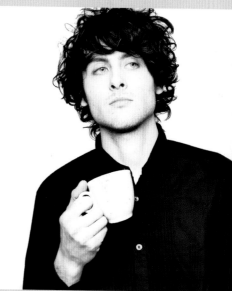

Tazza

You can't believe your eyes

There's absolutely no shame in editing a photograph, no matter what anyone says. Quite a lot of what we're able to do with digital post-production are things that were perfectly possible back in the old days of film and carried out in a darkroom. It's just that now anyone can edit their own images, and it has become a lot easier. Best of all, no one needs to go so far as to install a red light in their bathroom and lock bottles of developing chemicals away beneath the sink.

The absolute basic editing functions, which will I cover in the first three points of this chapter, can and should be performed on any photo that you take, whether you've used a smartphone or a DSLR. If you've used your smartphone to take the image, you can make those basic edits in-phone—they're that simple.

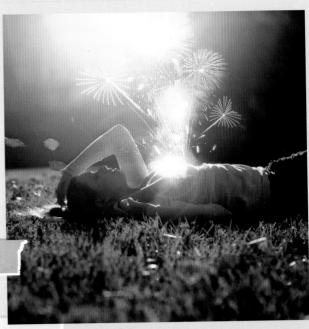

You're a firework by Danielle Pearce

For the more complex edits, you will find that you need a heavier-duty editing suite. I do virtually all of my editing using Adobe's Lightroom, but occasionally I need to crack open Photoshop. There are other options out there; it's a matter of finding the package that meets your needs at the price that you can afford.

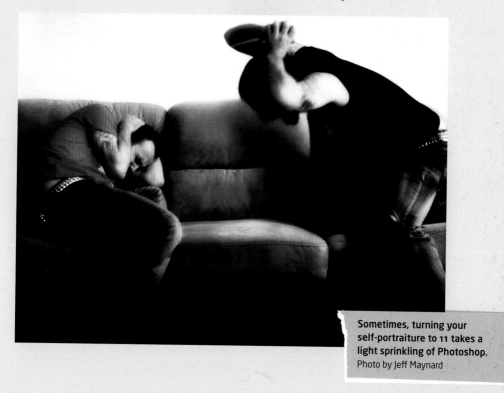

Sometimes, turning your self-portraiture to 11 takes a light sprinkling of Photoshop.
Photo by Jeff Maynard

Top ten tips for editing your self-portraits

Whenever you take a photo, whatever the subject, there are three basic edits that you should always consider making to it: crop, color, and contrast. They're the Three Cs and they have the power to elevate a photograph from something that's fairly ordinary to something a whole lot more special. Even if you've snapped something on your smartphone, you can still use a simple editing package to make these adjustments before you share the image on Facebook or Twitter.

1 **Crop:** Crop is fairly self-explanatory—it adjusts the parameters of the image to ensure that nothing extraneous detracts from the main point of focus. Getting in close to your subject is vital to taking good photos. You should be able to feel as if you can reach through the image and touch the subject, especially with portraits. It's hard to make a connection to a vague dot of a person on the horizon; it's far easier to feel involved with a photo that plays on someone's captivating green eyes. A crop can help you achieve this. Not only that, but it allows you to slice away an unfortunate sliver of background, to straighten the horizon, and organize the frame so that you're making the best use of the rule of thirds.

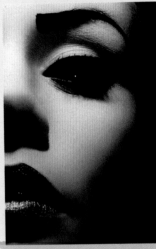

A careful crop can turn an okay photo into a masterpiece.
Photo by Lucy Tindall
(Lucy Tindall Photography)

The Rule of Thirds

The rule of thirds is one of photography's fundamental compositional rules; it's easy to remember and can vastly improve the impact of your photos. Having your subject in the middle of your frame can look flat, dull, and boring. Boring photos are definitely not what we want, so by repositioning our subjects off-center, we can make them livelier and more interesting.

The rule of thirds is an easy way to achieve this. Imagine that the frame is divided into nine rectangles, with two lines dividing the frame horizontally and two dividing it vertically. Anything running across the frame horizontally, like a skyline, should run on one of the horizontal lines. Anything positioned vertically in the frame—for example a tree—should be on a vertical dividing line. Key elements in the image, like someone's head in a full-length portrait, should sit on one of the four points where the lines intersect. These are called power points, or points of interest. It all contributes to the sense of dynamic flow.

2 Color: There are two parts to adjusting the color of an image: white balance and saturation. By adjusting the white balance to compensate for the time of day that a photo was taken and under what lighting conditions, you can be certain that white will look white, and not some odd gray-green.

If you're using white balance properly, you will shoot your images using a gray card and adjust accordingly in your editing suite. Alternatively, you could play with your camera's white balance settings or move the white balance slider in your editing suite until you reach a temperature that offers an accurate reflection of the colors as you shot them.

As for saturation, or the intensity of a color, it sometimes benefits from a touch of boosting. Saturation is usually controlled by a slider in your editing suite. Move it a few points to the right to boost saturation, or tone things down by shifting it to the left.

How you color-balance your photo depends on how you want it to touch your viewers. In this picture the warm colors project summer and innocence.
Photo by Carly Wong

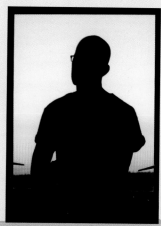

Contrast is of huge importance. In this case, I opted for extreme contrast, in the form of a silhouetted photo.
Photo by Haje Jan Kamps

3 Contrast: Contrast is the difference between the blacks and whites in an image. An image benefits from having its contrast upped a bit so that the differentiation between its lights and darks can be emphasized. You won't want to increase the contrast too much, because that can mean a loss of detail in your image. The idea is to bring a bit more punch, not leave it looking like a negative! Those are the basics, then, but what can you do in addition to the Three Cs to make your images sizzle, sparkle, and stand out from the crowd?

4 Shoot in Raw: Raw saves data just as the sensor records it, which means that when it comes to making edits, you have a great deal more latitude to make your image look how you want it to look, not how your camera thinks it should look.

5 Eyes: Eyes are the key feature of a portrait. Make sure they're in focus, check that the whites really are white, the pupils are a deep, dark black, get rid of any red veins, and emphasize the catchlight, or the small reflection of the photo's light source. If you've had the misfortune to take a photo that makes you look like a red-eyed devil, Lightroom has a correction feature for that!

6 Clean up: While I wouldn't advocate huge amounts of reconstructive Photoshop surgery, I have no objections to cleaning up spots and blemishes on skin, or removing stray hairs, and that includes my self-portraits. If they're not normally there, and aren't part of my normal perception of me, what's the harm in using Lightroom's Spot Removal tool or Photoshop's Spot Healing brush to clean up a pimple or two? Exactly!

7 Monochrome: Black and white portraiture looks timelessly elegant and is flattering to the subject. Skin tones are evened out, eyes sparkle, hair looks glossy, and people simply shimmer in monochrome.

If your camera has a monochrome setting, flick it on; if it doesn't, try a smartphone app or an editing suite. Snapseed has six different monochrome effects while Lightroom has a dedicated monochrome button that converts an image to black and white in one click. You might also want to try adjusting the red and blue levels in an image to alter the effect. By increasing the red tones, you will create a fairer complexion that minimizes blemishes and freckles. Ramp up the blues and you'll accentuate those features. If you're looking for a gnarled, wizened look, it might be just what you want. Just don't convert an image to black and white by desaturating it, or it will lose its warmth and intensity.

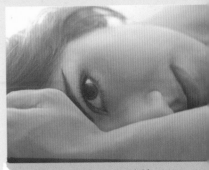

Eyes are absolutely crucial in portraiture; if you include them, know that this is where your viewers' eyes will be drawn before anywhere else!
Photo by Rosa Gonzales

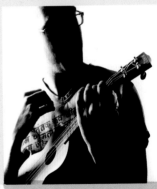

In this photo, I used the "exposure" brush in Lightroom to make my face a lot darker. I liked the feeling of an anonymous troubadour vibe created in this picture.

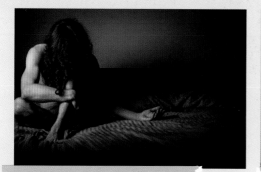

Black and white can be an extremely powerful tool in conveying emotions.
Photo by Todd Holbrook

To obtain beautifully crisp photos, ensure the source image is as sharp as possible, and apply a little bit of sharpening to it before publishing it anywhere—the difference is subtle, but intense.
Photo by Sydney Miller (Sydney Marie Photography)

8 Hair: If someone wants to change her or his appearance quickly, the first thing that usually comes up for consideration is hair, whether it's length, style, color, or all three. The best kind of editing that you can do to hair is dodging and burning. Dodging means to lighten something and burning means to make it darker. By burning the shadows and dodging the highlights, you can make your hair look sleek, glossy, and every bit as gorgeous as in a shampoo commercial.

9 Sharpen: The final step in your editing armory—always the last adjustment you should make—is to sharpen your images. You don't need to sharpen them a lot; an over-sharpened image will look horrible. Again, it's something that you can do using a mobile editing app or in an all-singing all-dancing suite.

Sharpening is about finding the right degree of definition so that your pictures aren't floppy messes or grainy heaps; play around with the slider until you reach the balance that works for your image. You'll improve with practice and just how much sharpening you need to apply will become intuitive to each image.

10 Frame: There are a lot of frames or borders that can be readily added to any image these days, so many that it could be thought of as rather cliché if you're not careful. But there are other ways of punching your image out from its edges—a delicate vignette, for example, might be just the trick to elevate a shot and pull attention in toward the center of the frame.

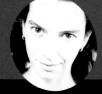

Introducing...

Daniela Bowker

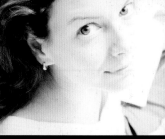

Daniela has gone to extreme lengths documenting her photographic discoveries on smallaperture.com. She writes about photography for a living now. She's been taking photos since she was five years old, or, as she puts it, "My father showed me how to focus an SLR, then thought better of it and handed me my Ma's Olympus Trip. I was given an Agfamatic for my seventh birthday and then a more advanced Pentax for my tenth birthday." Life got in the way for a little while, but eventually she acquired a digital camera and rediscovered photography in a big way.

Self in High Key

For Daniela, self-portraiture is a way to communicate. "It was (and is) a way to stay in touch with people I love; snap a picture of me doing something ridiculous, send it to them by MMS or email. If I get to make them smile (or maybe feel jealous), I've done my job.

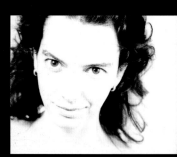

"Serious self-portraiture, with lights and timers and remote releases, started a few years ago as a means to teach myself more.

Piercing

I'm the most readily available, flexible model that I have. I am always on call, I can take as much time as I need, I can subject myself to ludicrous demands, and I know that the model and the photographer share precisely the same vision. Oh, and I don't cost myself anything.

"My photography does occasionally get me into trouble. I got myself locked in a churchyard during the August 2011 riots in London, for example. I'd wandered in to take some photos, as the light was beautiful and I really needed to focus on something that wasn't ugly or frightening for a few hours. The vicar hadn't noticed that I was there, and locked the gates early as trouble had been expected that night. The railings were well over six feet and spiky. Five-foot-one me was never going to get over them without disastrous consequences. A couple of phone calls later, however, and he returned to let me out and we both dashed home before things kicked off again."

For post-production, Daniela uses Adobe Lightroom, and cracks out Photoshop CS6 if she feels the need. She has some thoughts about when and what to edit: "You're never going to succeed at making a poorly conceived, poorly executed photograph look good in post-production. The image has to have a story, decent composition, and be properly exposed to begin with. The image needs to be as good as it possibly can in-camera. Post-production is a tool that we use to enhance our pictures and to add to the creative process.

"Lightroom is a tool in my photographic arsenal. Not only does it allow me to process one image in color, black and white, sepia, or with a cross-processed effect, it gives me control over the tones in a black-and-white or sepia version, or the type of cross-processing effect I want. I can even out skin tones and smooth away the odd blemish.

"As a medium, photography is a double-edged sword. It's used to record events for posterity and it is used creatively. There is a conflict. In some instances, it is meant to tell the truth, and in others, it is a representation of someone's vision of the world. It's a bit like words. We use words to attempt to tell the truth and record events (I say attempt, because bias as false reporting come into things) or we can use them to tell stories. Provided that people know which type of words they're meant to be reading—truthful ones or storytelling ones—they have no objections to their different uses. I'd like to think that we can respect photography similarly. If photography is meant to be recording events or selling a product, it needs to be truthful. If it is creating a vision, then it can be as fantabulous as the photographer wants it to be."

Equipment used
Daniela uses a Canon 450D for most of her photography, along with a Canon 50mm f/1.8. If she's not using natural light she uses a pair of Canon 580 EX II speedlites and a humongous reflector.

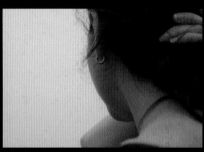

Hong Kong Cloud

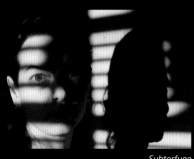

Subterfuge
** All photos by Daniela Bowker*

From Lightroom to Photoshop & back again

Of course, editing isn't just about making yourself look hotter. It can also be about making yourself look different and this can be achieved in the editing process. There is so much fun to be had with an editing suite. Just ask these guys...

Diana Ayoub

IMAGE	Euphoria
AGE	23
LOCATION	Jounieh, Lebanon
	flickr.com/photos/diana-ayoub-photography
	@diana_ayoub
WEBSITE	dianaayoub.com

SHOOT NOTES / MINI BIO

"I've only recently become comfortable enough to take self-portraits. I've discovered it's actually interesting being in front of the lens sometimes as well. What I find intriguing about self-portraiture is that I am not in complete control of everything. I can set the aperture, the exposure, the flash settings and prepare everything else, and still get a completely unexpected shot! It's a bit experimental and one of the most artistic kinds of photography because it is all about the photographer expressing themselves with themselves.

"I took this photo as part of a Project52 entry. It was week 30 of the project and the theme was euphoria. All week long I had this idea for a portrait of a face with an expression conveying complete euphoria, but in a calm way. Whose portrait? I thought a self-portrait would be the right way to go. During post-production, I chose to go black and white to emphasize that calm feeling. I left the lips red, highlighting a smile.'

Amanda Maddison

IMAGE **Electric**
AGE **18**
LOCATION **Ashington, UK**

@AmandaMaddison

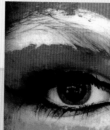

SHOOT NOTES/MINI BIO

"My interest in self-portraiture started as a required assignment on my photography course. I feel it gives me more freedom to express how I see myself, but more importantly, how others see me. Although I love taking photographs, I was a bit skeptical about photographing myself at first so I tried a few different images, copying the style of Cindy Sherman and dressing up as different musicians and actresses. I liked copying Sherman's style because it didn't feel like a self-portrait. It was more of a disguise of who I could be, but her styling wasn't right for me. Now when I'm thinking of my next image I play around with words that people use to describe me and develop my ideas and self-portraits from there."

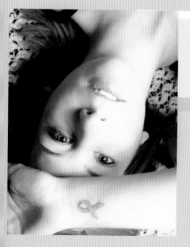

Riann Brown

IMAGE **Untitled**
AGE **20**
LOCATION **Flagstaff, Arizona, USA**

@riann_brown

SHOOT NOTES/MINI BIO

"I have always been a very shy and quiet person, never really being able to express myself around others. Taking self-portraits allows me to let loose, be creative, and feel beautiful without worrying about any judgment. I got the tattoo on my wrist shortly after a close family friend was diagnosed with breast cancer and treated with chemotherapy. Today, after nearly a year of treatment, she is cancer-free and living life to the fullest."

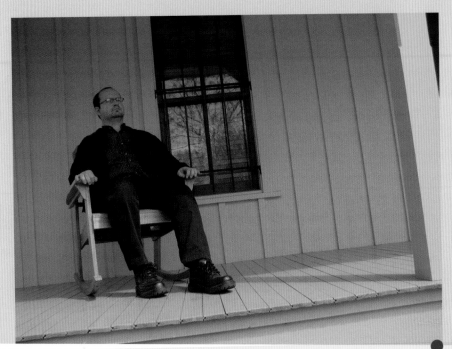

David Simmons

IMAGE	Pappy on the Porch
AGE	39
LOCATION	Conway, Arkansas, USA
	@DavidVSimmons
WEBSITE	davidsimmonsphotos.zenfolio.com

SHOOT NOTES / MINI BIO

"I was trying to achieve the look of a rustic Americana scene typical of the Ozark Mountains. It was, however, taken in an urban setting, at the Mount Holly Cemetery in downtown Little Rock, Arkansas."

You can't believe your eyes

Melissa Maples

IMAGE **Mixed Heritage**
LOCATION **Anatalya, Turkey**
🅱 @melissamaples
WEBSITE melissamaples.com

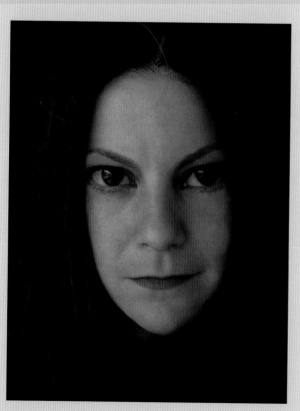

SHOOT NOTES/MINI BIO

"I started taking self-portraits because I felt that the photos other people took of me didn't show what I wanted to show of myself. Most people just wanted me to stand in one place and smile at the camera, and I find those kinds of shots so uninteresting. I didn't want to get to age 80 and look back at my younger years and just find hundreds of versions of the same picture of me over and over, standing there like a smiling statue, because that's what people think they're supposed to do when a camera is pointed at them.

"This photo was born from the hypothetical question of what I'd look like if one of my parents had been from another planet. Obviously this was more of an editing project than a photography project, but I had a lot of fun doing it."

Dave Patrick

IMAGE	Untitled
AGE	39
LOCATION	Los Lunas, New Mexico, USA
🄣	@davepatrick
WEBSITE	davepatrickphotography.com

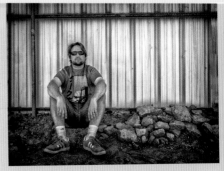

SHOOT NOTES/MINI BIO

"A self-portrait is the most complete (and usually difficult) experience a photographer can have. No hiding behind your lens. It's you out back, and in front of the camera.

"I was with my family attending an event at a local high school. I saw this metal wall, and the pile of rocks. Immediately, I saw myself sitting there and wanted a photo (I don't usually take very many self-portraits). In processing it, I wanted to go for a dirty, gritty look befitting of the environment, and black and white seemed to portray this best."

Corey Ralston

IMAGE	Untitled
AGE	32
LOCATION	Hanford, California, USA
🄣	@alacorey
WEBSITE	coreyralstonphotography.com

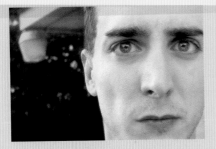

SHOOT NOTES/MINI BIO

"I discovered photography by taking self-portraits. As an actor it is a great challenge in conveying emotions. As an artist it is a great way to self-express. Having yourself as a model couldn't be easier. I remember spending eight or more hours a day in the beginning, photographing myself with a simple Sony point-and-shoot. I have come a long way from there, but love reflecting on that work. It trained me on portraiture."

You can't believe your eyes

Gary Chapman

IMAGE Here We Go Again • Face Plant
In Pieces
AGE 26
LOCATION London, UK
 @garychapman
WEBSITE garydchapman.co.uk

SHOOT NOTES/MINI BIO

"On January 1, 2011 I woke up with an idea for a shot. It involved me lying on the kitchen floor, butt-naked, with a keg of beer pouring into a cup in my hand with an exposure a few seconds long.

"That image was a big turning point for me. I started to think of photography as a way to tell a story or create something funny, rather than taking a picture of "a thing." Over the weeks and months that followed I came up with ideas I wanted to do, many of which I had no idea how to execute. With the aid of Photoshop I had to figure it out. I learned so much in this period just by doing, and with the shots being self-portraits it gave me the time, freedom and pressure-free situation to do this."

Here We Go Again: "This was the image I created for week 1 of 52 Weeks project. This wasn't my original concept, but I had to adapt and what I ended up with is one of my favorite images!"

Face Plant: "You'd be surprised how many people think I did this for real! I really wish the left foot wasn't cropped off, but that's what happens when you don't check your results properly."

In Pieces: "This was my first attempt at photo-manipulation with Photoshop. I was so meticulous with the shooting. I had a piece of paper covered in measurements of where each drawer was. This made the edit easy and for my first attempt at anything like this, I'm still pleased to this day. If this had not worked and spurred me on to do more, I wonder if I would still be doing photography now?"

Here We Go Again

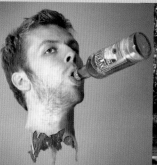

Face Plant

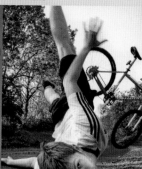

In Pieces

Andréia Takeuchi

IMAGE **My face, My soul**
Practicing my Skills
AGE 22
LOCATION São José, Brazil
WEBSITE andreiatakeuchi.com

SHOOT NOTES/MINI BIO

"Taking self-portraits is not easy. You really need to be in control of everything to make sure the final picture is as you want it to be, but I believe it's the best way to learn how to achieve a good picture."

Practicing my Skills: "For this photo I wanted to play around with photo compositing to tell a story and learn more about post-production, so the title *Practicing my Skills* is actually about the picture-making and the picture story itself. I added three pictures together to make this."

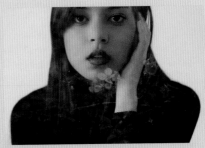

My face, My soul

Practicing my Skills

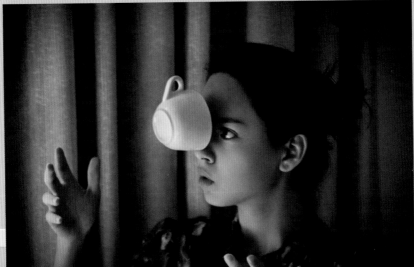

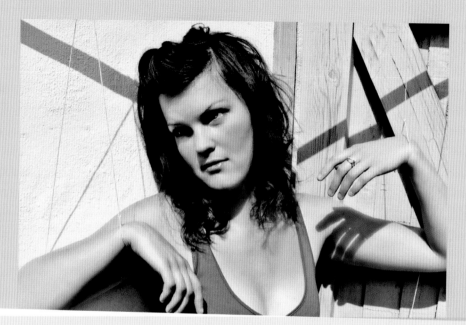

Claire Streatfield

IMAGE	On Strings
AGE	31
LOCATION	Maidstone, UK
WEBSITE	furwillfly.blogspot.co.uk

SHOOT NOTES / MINI BIO

"This shot was a nightmare to get! I had to tie the strings to a broom handle and balance it on my fence—and of course, it kept falling off, I kept falling over, and the camera kept turning itself off waiting for me. Eventually I got a puppet style pose and transformed it (with the help of Picnik) into a porcelain doll puppet. It's actually surprisingly difficult to achieve a glazed-over eye look, even if you try to think of something incredibly boring."

Telling stories

Every photo is about the story that it tells, whether it's fruit and vegetables piled high on a market stall or children splashing about in the sea, but sometimes you can push your concepts further and create an entire narrative with a picture. This is especially true with self-portraiture, particularly because when you're your own model, you can convince yourself to do anything! You can represent yourself as an entirely new person, you can act out a scene from a favorite book, or you can even recreate a fairy tale. You can be whoever you want or need to be.

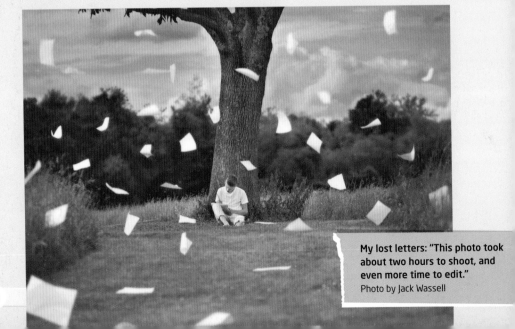

My lost letters: "This photo took about two hours to shoot, and even more time to edit."
Photo by Jack Wassell

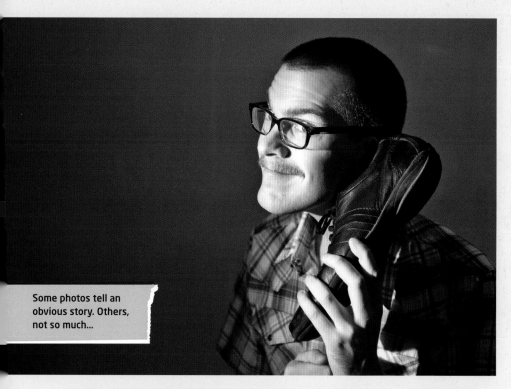

Some photos tell an obvious story. Others, not so much...

This chapter explores the people who use their self-portraiture to tell stories and the stories that they tell. If you feel inspired to try something similar, I'll show you what you need to think about to set up a storytelling shoot and make sure that taking pictures when you're on location doesn't descend into chaos.

Your guide to setting up a shoot

Location shoots are fun, exciting, and can produce terrific photography. They're also demanding, exhausting, and prone to going wrong. There are many variables to take into consideration, from the general public to the weather, and the potential for disaster is high. Shoots that involve props and costumes—even if they're not shot on location—also require meticulous planning. There is a way to ensure that you, your camera, and your tripod are able to realize the tale in your head.

All in the planning

The key to a successful location or storytelling shoot is in the planning. There will be factors beyond your control, especially with location shoots, but at least if you've organized yourself so that every eventuality is covered, and every need, want, and possibility is accommodated, the chances of success are greatly improved. When it comes to a shoot, you need a vision of your final images, a plan to achieve them, the costumes and props to create the scenario, and your photographic kit. You also need your location.

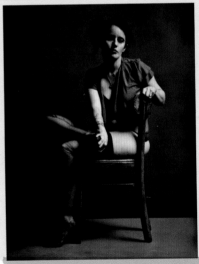

Without pre-visualization and planning, photos like this are extremely hard to pull off.
Photo by Aya Rosen

Visualize your final image

You need to be sure of what you're narrating before you get to your location, laden down with equipment and props, or set up your tripod in your garden. The first step to successfully telling a story through a photograph (or series of photographs) is to conceptualize your story and be certain of the vision you're seeking to recreate. What are you trying to convey to your audience? What mood do you want your images to have? How do you want those looking at your photos to feel?

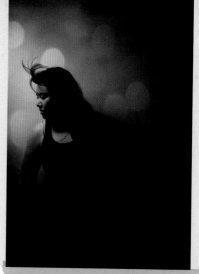

The concept of "self-portrait with bokeh" is easy. Actually making it happen is surprisingly tricky; visualizing what blurred backgrounds will look like takes a seriously experienced photographer.
Photo by Sodanie Chea

Sketching out how you'd like your final image, or series of images, to appear will help you to ensure that you have everything that you need as well as make life easier when it comes to taking the photos. I know some photographers who are meticulous at creating diagrams in Photoshop and others who sketch out their ideas on the back of an envelope. You might prefer to opt for something in between, but certainly for a series of images, it could be useful to set it out like a storyboard, so that you won't miss any details or skip a step.

However you choose to map out your narrative, knowing what you're aiming for will help to prevent your shoot from descending into a chaotic fiasco that doesn't achieve anything.

Scouting your location

When you've imagined the story you're planning to tell, the next step will probably be scouting the location to shoot it. If it's in your dining room, life will almost certainly be a hundred times easier than a supermarket parking lot, but don't let that put you off.

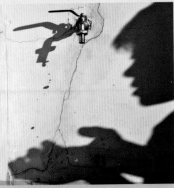

Sometimes, you have to wait for the light to be absolutely perfect before you can achieve your vision.
Photo by Elis Alves
(Elis Alves Photography)

You are going to have to do some research into your location before you rock up and start taking photos there. First, and very importantly, is your chosen location publicly accessible? Just because an orchard in full blossom is the setting you've envisioned for your tree spirit self-portraits, it doesn't make it any less private property. If you ask the owner politely, she or he might well grant you permission to take photos one evening, but you can't just wander in.

It's not just about the boundaries between public and private. The gorgeous plain of heather that's inconveniently behind a barbed wire fence could well be out of bounds because it's a firing range; a farmer might have posted an enormous "No Entry" sign on the gate to a perfectly rolling verdant field because that's where his Jersey bull is grazing; and the stony ground at the base of the waterfall of your dreams might be roped off because recent rainfall has made it unstable.

Once you have established the accessibility of your location, there's still information that you're going to need. If you're shooting at the beach, when are low- and high-tide? Is a particular area of a forest home to animals or plants that are protected, might attack you, or induce allergic reactions? From which direction will the sun be shining at the time of day you'd like to shoot? Do your research. it will make your life a lot easier!

Create, plan, and write an inventory

Once you have mapped out your story and scouted your location, it's time to get into the detail of the planning. You will need to prepare an inventory of the props and costumes you'll need to create the scene, as well as the photographic kit to shoot it. In addition, you will need to write a plan. Do you need to borrow any equipment? If you're shooting on location, at what time do you need to be there to catch the right light or avoid the crowds? How do you plan on reaching your location and how long will it take you? Do you need a packed lunch as well as something to drink? How long do you anticipate setting up your shot will take?

It's also worth considering if you might need an assistant. If you're not accustomed to shooting with other people, it can be disconcerting having someone else watch your every move, but do not underestimate the benefit of an extra pair of hands and eyes to keep watch over your kit, to wield reflectors, or to help usher people out of the line of the camera when you're half way up a water tower—even just to have some company. It's also worth bearing in mind that if you're at a remote location, there is safety in numbers. If you're not planning on taking an assistant, let someone know where you're going and what your plans are. Don't forget a contingency plan in case of rain, etc.

When you've made your list, checked it twice, and are on your way, all that is left is to enjoy taking your photos. Remember: photography is meant to be fun. You shouldn't be miserable with a camera in your hand, or on a tripod, in the case of self-portraiture.

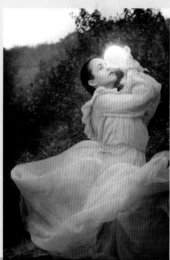

Location shoots take a lot of planning, but the results are all the more eye-catching.
Photo by Sarah Allegra

Introducing...
Whitney S. Williams

Whitney is an incredibly inspirational photographer whose photos will make you feel lazy. Her work is a testament to the fantastic results that can be achieved when you bubble over with ideas and have the tenacity to follow through on them. She's one of those rare photographers that make me reach for my camera instantly, because she fills my brain with new ideas.

Based in Jonesborough, Tennessee, Whitney has a BA in art and is working as a photographer, fashion editor, and stylist. She has been taking photos "for ages," but started taking conceptual photos about seven years ago. She started taking self-portraits five years ago, mostly out of necessity: "When there is nobody else around when you are in the mood to take photos, it makes sense to use the only model you consistently have available: Yourself!

"Being both behind and in front of the camera is no easy feat, and I love the challenge. I learned that it was not only a cathartic process, but also one that was fulfilling artistically."

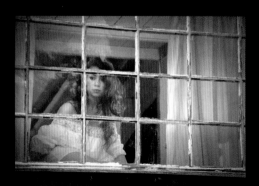

Window

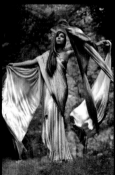

Ascension

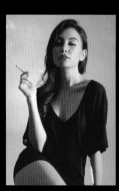

A Woman

Whitney uses photography as a way of acting out alternative personas—or the Whitney that could have been, had she chosen another path in life. In other photos, she draws inspiration from things that happen spontaneously. "While living in the woods with no neighbors for several years in the mountains of Tennessee, I would use the landscape as the backdrop for much of my photography. One day while attempting a self-portrait outdoors, a strange noise came from the woods, almost like a howl. It was loud enough to be frightening but far away enough to be out of sight," she recalls. "Instead of going indoors, I decided to work with my emotions of the moment, and it allowed for some very mysterious and haunting photos (see *Lantern in the Snow*). I never learned of the creature making the noise, and it may forever remain a mystery.

"I've always been drawn to the idea of the what-if versions of the self. The idea of many possible selves was presented to me while studying psychology. I find it infinitely interesting that a small moment in one's life can change the course of their career, love life, etc." Whitney says, thoughtfully. "Much of my work is based on this idea, and while I only get to live one real life, I like to use self-portrait photography as a vessel for living, albeit briefly, as those other possible selves."

* All photos by Whitney S. Williams

Equipment used

Whitney originally worked with a Nikon D200 with various lenses and SB-600 Strobes. She now uses a Canon 5D Mark III with a Canon lens and adapter with original Nikon lenses.

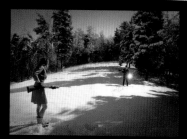

Reindeer Games

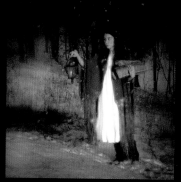

Lantern in the Snow

John Magruder is another incredibly versatile photographic artist. When I first saw his work, I was struck by how cinematic his photos are, as if they are finely-crafted still frames from a movie. I think that perhaps this is one of the strongest draws to his photographic style—the feeling that you are getting a tiny fragment of a story. The context is missing, but you're still getting a snippet of what is happening.

John is a 43-year-old father of two based in Chicago. His day job is a massage therapist and massage therapy instructor. About two years ago, he decided to embark on something new, and committed to doing a 365 day self-portrait project. "My original idea was that I could get myself to a point where I would have the confidence to take a good photograph anywhere under any conditions," he says. "It may not have turned out entirely the way I expected—I certainly have learned a lot!" he adds, laughing.

"I have really been interested in photography since high school," he says, but admits that his interest has been waxing and waning for many years. That changed when he became a parent, however: "I bought my first digital SLR and I have been working hard at it ever since."

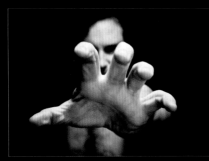

Untitled Self-portrait

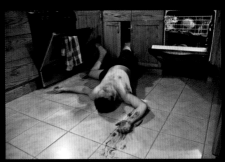

Untitled Self-portrait

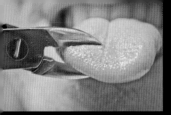

Untitled Self-portrait

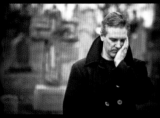

Untitled Self-portrait

To John, self-portraiture is an expression of himself. "While many of my images are dramatic and not how I am on a day-to-day basis, they all reflect a certain part of who I am and the life I have been living. Whether inspired by the music I listen to, the books I read, the hobbies I have, or the work I do, it is all aspects of me in those photos."

John's usual starting point for a self-portraiture session is a checklist. "I actually got my hands on a little old notebook and sit down on a semi-regular basis and just write in ideas that I have for a portrait. I don't censor myself. Just put down any ideas that come into my head: feelings I want to express visually, props that I see that I think might be interesting, scenes from movies that I remember, stories I am drawn to from the news or books or wherever, places that I like... it doesn't matter. Then what I do is refer to this little book when I don't have something specific in mind that day. It can help give me some direction, if not exactly what to do for a shot."

* All photos by John Magruder (John Magruder Photography)

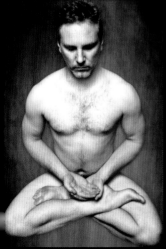

Untitled Self-portrait

Bring on the bards

From their own mini-dramas to the recreation of stories, these are all pictures with an underlying tale. Sit down, relax, and let the drama unfold.

Sarah Allegra

IMAGE **Where Dreams and Shadows Lie Unmarked**
AGE **31**
LOCATION **Altadena, California, USA**
 @sarahallegra
WEBSITE **sarahallegra.com**

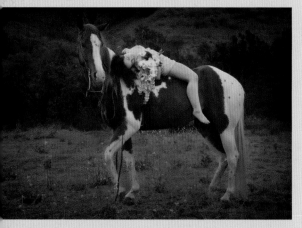

SHOOT NOTES / MINI BIO

"A few years ago, I was doing a lot of modeling for other photographers. I kept getting ideas I thought would make great photos, but the photographers I was shooting with were rarely interested in them. And while I really enjoyed modeling for other artists, I eventually decided to take matters into my own hands and start bringing my concepts to life myself. That's where it all started.

"A good friend of mine has a horse, and one of the things that makes her such a good friend is that she was more than happy to get up before dawn with me so I could take a self-portrait draped over her horse. Freddy, the horse, is an excellent model, by the way!"

Dale Moore

IMAGE	**Shooting Myself**
AGE	**21**
LOCATION	**Kannapolis, North Carolina, USA**
WEBSITE	dmphotography.com.nu

SHOOT NOTES / MINI BIO

"I have always wondered how other people saw me. So I started to take photos of myself to get an idea of what I looked like in other people's eyes."

Elis Alves

IMAGE	**Untitled**
AGE	**37**
LOCATION	**Curitiba, Brazil**
WEBSITE	elisalves.com

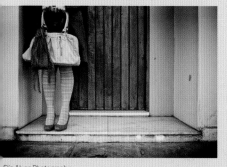

Elis Alves Photography

SHOOT NOTES / MINI BIO

"I started a self-portrait project because I needed something to keep me sharp, photographically speaking. I was a new photographer without much work and in need of a challenge. I hated posed photographs and didn't like to be photographed. So 365 self-portraits with no Photoshop seemed to be the way to go in order to stretch me creatively. And that's what I did. It improved my eye for color and developing concepts visually, as well as my photography as a whole.

"I still don't like being the model, but I have grown to love conceptual photography and am now behind the camera for some conceptual shoots I would have never tried before."

Simon Withyman

IMAGE	**Rushower**
AGE	**29**
LOCATION	**Bristol, UK**
WEBSITE	simonwithyman.com

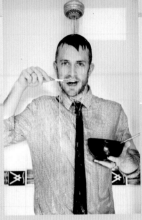

SHOOT NOTES/MINI BIO

"I started taking self-portraits as a way of testing a new concept that I wished to experiment with using a model, but what developed was actually a small set of photos that I was quite pleased with.

"The idea for this photo popped into my brain as I was rushing around doing a hundred and one things. I thought that the concept of extreme multi-tasking during my morning routine could make for an amusing photo. It was shot in my shower, with my camera on a tripod and ambient lighting with my girlfriend holding a reflector to bounce light into the shower. I had to ensure that the shutter speed was fast enough to catch the water's movement. It was not viable to get close to the camera as I was soaking wet! So I relied on my confidence in the settings I had chosen and my girlfriend's feedback on expressions."

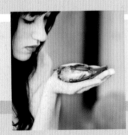

Carly Wong

IMAGE	**A Matter of life and Death**
AGE	**30**
LOCATION	**Bristol, UK**
🐦	@squidzero
WEBSITE	Squidzero.com

SHOOT NOTES/MINI BIO

"I was wandering down the road when I spotted something in the gutter and realized it was a bird. It wasn't squished, just expired. It felt wrong leaving her, so I took her with the intention of burying her. When I picked her up she was not at all what I presumed death to be, she was just a velvety bird that was no longer alive. I sincerely hope this image does not offend. Prior to her burial I wished to take a picture which conveyed the delicate nature of her situation and continuing beauty in death."

Sarah Peacock

IMAGE	**Realign**
AGE	**25**
LOCATION	**East Arlington, Vermont, USA**
WEBSITE	sarahpeacockphoto.com

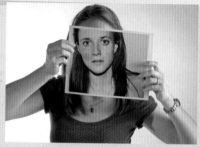

SHOOT NOTES / MINI BIO

"Taking photos of myself was always nerve-wracking. I had, unintentionally, always photographed myself partially hidden behind something or through a reflection. There is a certain level of comfort that comes with staying behind the lens. There, I can create and control how I want an object to be seen. When in front of the lens I feel vulnerable and awkward because the camera may highlight some of my flaws. As a way of overcoming this, I snapped a quick headshot of myself with a small digital camera. Doing this alone in my room helped to take the pressure off. I could make a quick print of the photo and then spend the rest of my time in the studio working on lining up the image correctly. With my face hidden behind a piece of paper, I felt safe. The final photograph came out with a fun push and pull of what is real and what is manipulation."

Sydney Miller

IMAGE	**Directed Vision**
AGE	**21**
LOCATION	**Ferrysburg, Michigan, USA**
	@LOLSYDNEYMARIE
WEBSITE	sydneymariephoto.com

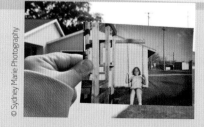

SHOOT NOTES / MINI BIO

To reflect back on my childhood, and how things have changed, I went through my parent's old photos and pieced them into the present by holding the image in front of me. My goal was to do everything in-camera.

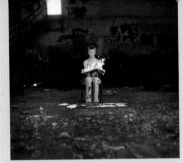

Ashes of My Past

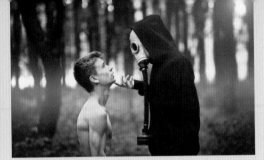

The Harbinger

Jack Wassell

IMAGE	Ashes of My Past
	The Harbinger
AGE	21
LOCATION	Monroe, Connecticut, USA
WEBSITE	facebook.com/jackwassellphotography

SHOOT NOTES / MINI BIO

"For me, self-portraiture is different to all other types of photography in the sense that it allows me to tell a story or concept. I find inspiration for my self-portraits from a variety of different things including personal struggles or achievements, music, books, or religion. I always leave my images open to interpretation because I love the different reactions I receive, and also because I believe it helps the viewers connect to the photo in their own personal way."

Ashes of My Past: "This was taken in an old abandoned warehouse. I love including fire in my photos because of the many different ideas it can represent, and because it always comes out looking awesome. This is actually about 20 different images manually blended together in Photoshop to achieve a higher resolution and much shallower depth of field. Using this technique also helped me capture more of my surroundings than I would have by just taking one shot. In post-production, I wanted to use colder tones to provoke a darker mood, and to contrast with the glow of the flames."

The Harbinger: "This image is part of a photo series I made with a gas mask. When I first saw this mask online, I knew I had to buy it so I could include it in my self-portraits. I love the strong and creepy mood it provokes, and I think it can tell a lot of different stories. There are two other images that are part of this series, and I plan on creating more."

Anna Lucylle Taschini

IMAGE	It's a Trap!
AGE	33
LOCATION	Milan, Italy
	@annalucylle
WEBSITE	lucylle.com

SHOOT NOTES / MINI BIO

"As an art director for an advertising company, it's compulsory to scour the web for what's cutting edge. As a consequence, I get my fair share of memes and "It's a trap!" is one of my favorites. When I got myself a set of Star Wars legos, a friend commented that I was getting too old for that sort of toy. This self-portrait is my answer: sticking stuff up the nose or in the mouth is what a child does when exploring new things. It's a reminder to always be inquisitive and not to let routine trap you. This is a composite. It's physically impossible to stuff two nostrils while also trying to emote, so I had to blend half of the nose between two shots."

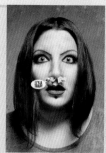

Danielle Pearce

IMAGE	I Found Some Kind of Fairytale
AGE	18
LOCATION	Virginia Beach, Virginia, USA
	@_DaniellePearce
WEBSITE	daniellepearcephotography.com

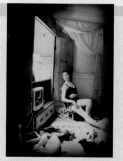

SHOOT NOTES / MINI BIO

"Being able to shoot with myself was extremely easy, because both the model and the photographer are on the same page as far as ideas go! I started out with self-portraits, and three years later, they continue to help me progress in my work.

"In this photo I was trying to capture something magical yet fairytale-esque. I loved the feel of the light coming from the wardrobe. It was taken in my little sister's bedroom. I liked this photo because I could see the hope in my face. The chaos of the bedroom created a trapped environment, and the light from the wardrobe provided a hopeful sort of feel for the girl!"

Get dressed up—or down

Half the fun of self-portraiture is being able to present yourself as someone completely different. If, like me, you rarely venture out of jeans and a t-shirt, getting dressed up for a photo shoot is a great deal of fun. Or, if you wear a suit every day to work, why not try something entirely different, like a period costume? How about trying some extreme make-up, or donning a wig? You could even push the boat out further and try fancy dress!

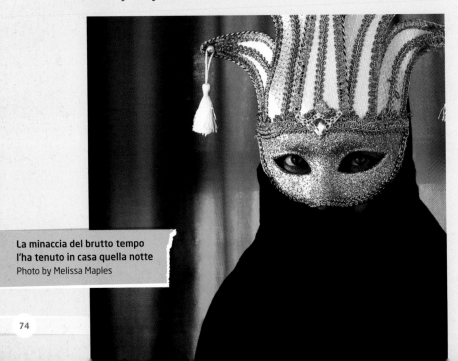

La minaccia del brutto tempo l'ha tenuto in casa quella notte
Photo by Melissa Maples

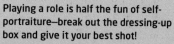

The possibilities with self-portraiture extend as far as your imagination will let them wander, so if in your wildest dreams you've always imagined playing an Ancient Greek courtesan or a nineteenth-century pirate king, go with it. This is your opportunity to be whoever you want to be.

Top Tips for taking photos in the mirror

When you get dressed up, I bet that you use a mirror, don't you? Mirrors are also one of the most frequently used means of capturing self-portraits, especially if you're not confident using a Self-Timer. In a way, it's a shame that mirrors are so often regarded as expedient rather than creative, because they can contribute to some gloriously inventive self-portraits.

Seeing as we're getting dressed up, I thought that this would be the perfect opportunity to look at how to make the most out of a mirror.

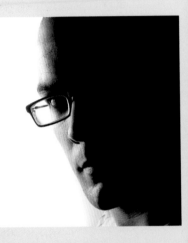

Taking photos in the mirror is a great way to visualize your photos, although I tend to re-shoot my photos without a mirror to increase the quality and sharpness of my shots.

You and your reflection

Before you grab your camera and locate the nearest mirror to assume your role as the next Narcissus, you need to think about the kind of portrait that you're aiming to shoot in the mirror. Do you want it to be just your reflection, or do you want it to be of you and your reflection? This isn't just important for the look and feel of your portrait, but also how you go about shooting it.

To take a photo that includes both you and your reflection, you will find it far easier to mount your camera on a tripod (or some other stabilization device), together with the Self-Timer function or a remote timer, than to attempt to handhold it. When you're setting up the shot, think about the point of focus, too. Do you want your reflection to be sharp, or you? If you get your story straight, the shoot will be much more straightforward.

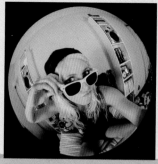

Using the mirror as an integral part of your photos can work well for some shots.
Photo by Natalie Vaughan (NatVon Photography)

You, your camera, and your reflection

There's nothing wrong with including your camera in your self-portrait, but you need to be aware of how you and it are positioned when you take the photo. It's far too easy to get distracted by your camera and find yourself looking at your controls or screen, rather than in the mirror or wherever you're supposed to be looking. It's also too easy to end up with your arm emerging from your head like a deformed trunk as you struggle to hold your camera above your head, or your camera sitting like a devil on your shoulder, or even completely obscuring your face as you try to get your reflection into your image.

Start easily, and work your way toward more complicated poses as you grow more confident taking reflective portraits. If you have access to a large or full-length mirror, try sitting down with your camera in your lap. And remember to look in the mirror, not at your camera!

Shooting with a mirror is a great way to get a "feel" for what's going on—but it's a learning tool, more than a photographic prop.

Getting the angles right

The key to mirror self-portraiture is to get your angles right. Your angles are vital so that you (or your reflection) are in focus, the foreground isn't a vast expanse of carpet, and if you're concealing the camera, it isn't visible.

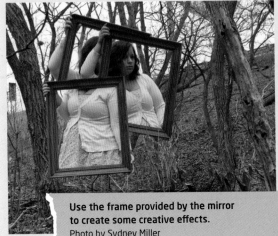

Use the frame provided by the mirror to create some creative effects.
Photo by Sydney Miller
(Sydney Marie Photography)

Taking a photo in the mirror with the camera directly before it will result in the camera being visible in the image. If you are attempting to conceal the camera, try shooting from an acute angle to the mirror. Gradually shift the camera from directly in front of the mirror further in an arc to the left or right, until it reaches a point where you are able to photograph your reflection, and you as well if that's your intention, without the camera recording its own reflection. Experiment with positioning your camera low down or up high. This will not only create interesting compositions, but it will affect the feeling of the self-portrait and people's perception of you. If you want to appear dominant and powerful, loom over the camera; to come across as tentative or submissive, opt for a high camera angle.

Not using a flash is the first rule of taking photos that are direct reflections in a mirror. If you use flash, it will splatter a lightning bolt across your image. If you're using off-camera lights, you can angle them to ensure they're lighting the scene but won't bounce straight off the mirror. With smartphones and compact cameras, make sure the flash is off and that the scene is well-lit with ambient light.

It's easy to think of using a mirror as a means to an end to shoot a self-portrait.

There's a reflection of you, there's a camera, there's a self-portrait. Rather than being so mercenary, how about making the mirror a feature of the self-portrait? Think about including the mirror as part of the story. Attempting to recreate a scene from the Lady of Shallot is ambitious, but it is something to aspire to. Meanwhile, try shooting yourself applying your make-up.

Remember, you don't have to use a mirror that hangs on a wall. Some of the most effective self-portraits shot using mirrors haven't been ceiling-to-floor mirrors, but handheld compacts. They create intimate self-portraits that are discreet, or suggest something more sultry.

A mirror doesn't have to be a looking glass

Other reflective materials can be used to create self-portraits. Virtually any polished surface will produce a reflection. Glasses, sunglasses especially, make brilliant mirror-like surfaces. Perfectly still water can create almost-perfect reflections, and rippling water can produce a shimmering effect. Christmas tree baubles, windows, polished granite, or polished metals all have potential. For a philosophical exploration of self-portraiture and the process of allowing someone else to look at you through your own eyes, you could shoot yourself as a reflection in someone else's eyes.

Using a stroboscopic light enabled me to take this somewhat creepy-looking self-portrait, where I've included seven photos of myself in the same frame—without using Photoshop! Without a mirror, I wouldn't have had a chance to capture this one.

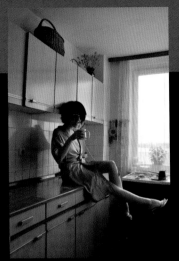

Sanja is one of those photographers who comes with an almost impossible range of styles. She is a professional hair stylist by training, which in turn sparked her two most passionate hobbies, make-up and photography, the latter of which she now considers her profession. She started taking photos in 2006, but didn't get serious about the art form until about three years ago.

Initially, Sanja started taking self-portraits out of necessity. As a hair stylist and make-up artist she had a lot of different ideas that she wanted to test on herself before she tried them on models. "With time, I started liking the ability of drastic change in looks throughout each session."

Untitled Self-portrait

Many of the shoots Sanja does are the result of a spur-of-the-moment direction for an experiment. "I like creating the magic of the moment around me," and she admits that as soon as the magic goes away, she gets bored, and abandons the shoot.

"I am actually a very shy person," she says and explains that she doesn't particularly enjoy being photographed by others. "Something changes when I take charge of the empty room and my camera. When I get alone time with my own ideas, it's easy to reject all traditional rules and put the mask on. I like seeing those different personalities in my photos."

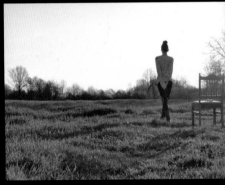

Untitled Self-portrait

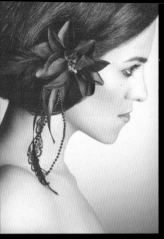

Untitled Self-portrait

Equipment used

Sanja uses a Nikon D90 with standard lenses AF-S NIKKOR 18-105mm 1:3.5-5.6G ED, portraiture lenses AF NIKKOR 85mm 1: 1.8D, Visico light stand LS-8008K, studio flash Vistar VS-300A, Visico SB-030 Soft Box 60 x 90, and radio trigger Visico VS-604 AC.

"My self-portraiture journey started out being about pure fun. Eventually, I ended up realizing I love to look at the world through the lens. It is amazing how you can leave out all that is bad and ugly, and focus only on the positive and pretty." Of course, the same applies to self-portraiture. "I like creating a vision of myself that is totally different to every-day Sanja. I still feel hungry for more, for improvement, for more stories to tell through my self-portraiture," she concludes.

* All photos by Sanja Peric

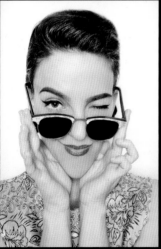

Do you get my picture

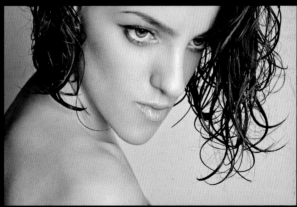

Wet Hair, Cold Skin, Part II

Putting on the Ritz

These ladies and gentlemen know how to put on a show: from ball gowns to animal masks via mirrors and make-up, they've glammed up and have some awesome photos to show for it!

Jena Ardell

IMAGE **Time Traveler**
AGE **28**
LOCATION **Asbury, New Jersey, USA**
 @JenaArdell
WEBSITE jenaardell.com

SHOOT NOTES / MINI BIO

"I adore the fact that—unlike digital images—Polaroids are tangible and one-of-a-kind. Once the image ejects, I am holding a photograph of a character—someone who looks like me, but isn't me at all.

"This is the most accurate self-portrait I have shot to date. Vintage clothing + vintage luggage + vintage furniture + Polaroid camera + beach house (with vintage wallpaper) = 100% me."

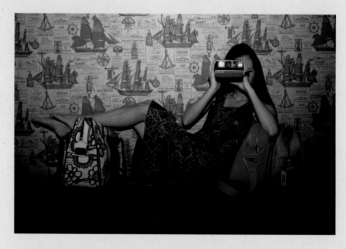

Elly Lucas

IMAGE **Space**
AGE **22**
LOCATION **Sheffield, UK**
🅣 @ellylucas
WEBSITE ellylucas.co.uk

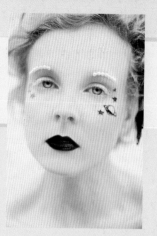

SHOOT NOTES / MINI BIO
"I've always adored creative styling and use of color. Quite often if I've thought of a look I'd like to use in a shoot sometime, I'll test it out on myself first to make sure I a) know how to do it and b) know it won't be too traumatic for the model! Plus it's just fun to dress up and pretend to be a rock star every now and again."

Claire Streatfield

IMAGE **Ouch!**
AGE **31**
LOCATION **Maidstone, UK**
WEBSITE furwillfly.blogspot.co.uk/

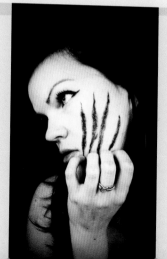

SHOOT NOTES / MINI BIO
"When I completed a 365 self-portrait project it was a great way to gain confidence with my camera, and a brilliant excuse to pull out the dressing-up box and act like a kid again. The best bit, though, is that I've got a willing model for all the crazy photo ideas I come up with! Temporary tattoos can be great for horror style shots, and I love how real this looked!"

Leslie June

IMAGE **Goodbye Babylon**
AGE **24**
LOCATION **Asheville, North Carolina, USA**
 @leslie_june
WEBSITE lesliejune.com

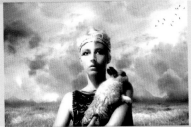

SHOOT NOTES/MINI BIO
"Self-portraits allow for my ideas to transcend. At times, I cannot express in words what I'm hoping to create, so I go off on my own. The entire photo shoot then becomes this spiritually-charged experience where I grow in a meditative, artistic environment."

Beth Retro

IMAGE **Vintage Summer**
AGE **29**
LOCATION **Maldon, UK**
WEBSITE **bethretro.com**

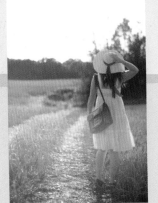

SHOOT NOTES/MINI BIO
"Self-portraiture is such a great thing for a photographer. It is a wonderful form of self-expression and a method of truly reflecting inner feelings in an image. I think the best thing about self-portraiture is the control it gives the photographer. You know exactly what you want to convey and as the model you are much more likely to achieve this. There's something simply natural about self-portraiture and every photographer should experiment with it at some point.

"This self-portrait was taken on a summer evening in the English countryside. I am fond of the vintage style and enjoy reflecting this in images. I wanted to create a nostalgic mood, like a memory. My favorite time to take photos is during the golden hour. Choosing to take this photo an hour before sunset has given it a soft glow which I feel adds to the mood."

Ice Foxx

IMAGE **Foxx in a Hoodie • Aidan Dalmatian Gas Mask and Fire Helmet**

AGE **29**

LOCATION **Winkler, Mannitoba, Canada**

 @ice_foxx

WEBSITE photos.icefoxx.info

SHOOT NOTES / MINI BIO

"I started to get into photography about five years ago. What helps my self-portraiture is that I enjoy wearing unique clothes and costumes. The subject matter isn't 'mainstream,' and with the latex outfits it can get racy, but the photographs are less about me and more about the created characters and situations. It's fun to be silly, dress up, and take pictures of oneself every once in a while!

Aidan Dalmatian: "This is one of my favorite self-portraits. What I love are my eyes. They're not my favorite physical feature, but here they're intense. I had a moment of inspiration to add the text in the background. I've always thought that this photo feels like it could be the cover to some kind of novel."

Foxx in a Hoodie: "I took this photo because I had just bought that hoodie and I thought that the colors in the hair would go well with it. No flash was used, and all the lighting is natural."

Gas Mask and Fire Helmet: "I took this photo to use it for various icons and avatars around the internet for my music projects. I was going for somewhat of a Daft Punk, not-quite-human feel. I always loved those fire helmets, and the gas mask underneath really completes the look."

Foxx in a Hoodie

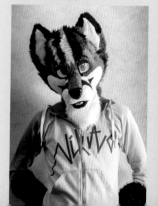

Aidan Dalmatian

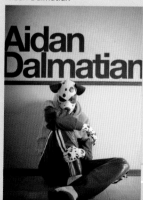

Gas Mask and Fire Helmet

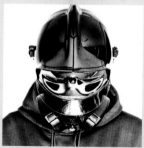

J. G. Hernandez Jr.

IMAGE **Untitled**
AGE **27**
LOCATION **Winter Garden, Florida, USA**
🅣 **@vmpphoto**
WEBSITE **vmpphoto.com**

SHOOT NOTES/MINI BIO

"Self-portraits allow me to express myself and connect with my art. I started off using myself as the model for concept tests. I started to like some of the test shots better than the intended finals. A lot of photographers would rather be behind the lens, but I love being in front of the camera!

"I am a big fan of Norman Rockwell, so I decided to create a photo inspired by his triple self-portrait (with the camera representing my other 'self'). I spent about three hours adjusting the lights and the mirror and the only thing that I forgot was to put the rag in my back pocket. I guess I could have done it in Photoshop in a fraction of the time that it took, but where's the fun in that?"

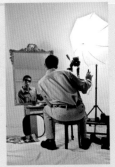

Samantha Scholl

IMAGE **Sam Fairy**
AGE **29**
LOCATION **London, UK**
🅣 **@samlscholl**
WEBSITE **samanthascholl.com**

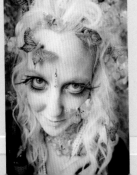

© Sauriel Photography

SHOOT NOTES/MINI BIO

"I started off my photography with a challenging little self-portrait project to kickstart the first in my series, 'My Spiritual Journey through Life,' where ying+yang life experiences mesh into surreal fantasies of real life.

"This was one to capture the essence of 'Sam Fairy,' my inner dream-like character. I was the only one involved in bringing the project to life. I set up my camera, conceptualized and styled the whole shoot, and did my own hair and make-up! I had a great time!"

Anna Lucylle Taschini

IMAGE	Self-portrait with megalomania
	Rule 63
AGE	33
LOCATION	Milan, Italy
🅣	@annalucylle
WEBSITE	lucylle.com

SHOOT NOTES / MINI BIO

"I view photography as personal expression, both of the subject and the shooter. This is doubly true when it comes to self-portraiture. Knowing exactly what I want to shoot and how to express it means that I have more control over the final outcome. I see self-portraiture as research. The photographer is the perfect lab rat on which to experiment techniques that otherwise might not be done."

Self-portrait with megalomania: "This was an unplanned self-portrait and the way it was made goes completely against my usual work method. I rented the tricorn hat for a pirate shoot for a client, but decided to have some fun with it as well. I thought that on me it looked more like a general's hat than a pirate one, so I assembled an outfit that brought forth a sort of Napoleonic, military vibe.

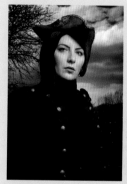

Self-portrait with megalomania

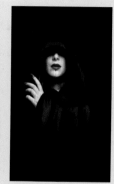

Rule 63

"I shot on a white background, faded to black by the use of restricted lighting, trying to pose in ways that were similar to the aristocratic portraits of the time. Post-production was done entirely in Photoshop to give the image an antique mood. The title is tongue in cheek as I'm normally a very easygoing person that shies away from positions of authority."

Rule 63: "Rule 63 is an internet adage that states that for every fictional character, there exists a counterpart of opposite gender. I'm one of those people who usually roots for the evil guy in movies or books. The villains are better dressed, they get more interesting stories and motivations than the average do-gooder, and thanks to the fact that producers and authors lately have realized there's a market for evil-lovers, too, they aren't as ugly as they were in the past. Combine the two and you get my personal interpretation of Emperor Palpatine from *Star Wars*, if he was indeed an Empress."

Put your game face on

Not every self-portrait needs to be you looking your absolute best, but there is a practical purpose for a shot that makes you look hot.

You may snicker at first, but online dating stopped being a social taboo some time ago. These days, one in five new relationships is initiated through an online dating service—and that trend is only continuing to grow.

While each dating site is different, and many place considerable weight on personality tests, biographical essays, and messaging, the self-portrait invariably has the biggest effect and draws the most attention, at least initially. Given that, you'd think you'd see more creativity and thought put into this important piece of the dating puzzle—but you'd be wrong. The vast majority of online-dating self-portraits are mundane, shot-in-the-bathroom-mirror iPhone photos that reveal nothing in the way of personality and character. Knowing that, it follows that putting even a little bit of effort into your online-dating self-portrait will give you a significant leg-up.

A posed, studio shot can still be genuine...

...And a costumed shot can still show off your character.

While most of the advice throughout this book applies in equal measure to this particular type of self-portrait, I'll give you two straightforward pieces of advice that are virtually guaranteed to draw attention. On the one hand, you have your straightforward, but technically flawless glamour shot. It's better than a candid, in that it shows off your features at their very best—the key is to still make it a genuine reflection of your personality, which means eye contact, a heartfelt smile, and natural (but flattering) lighting. The other super-successful online-dating self-portrait is more surreal and creative, but in a way that showcases your spirit and character. You can look different, but in an intriguing rather than intimidating way. The key in any case is to display both your personality and creativity.

Getting saucy

Nude, naked, starkers, bare, au naturel, in the buff... none of them come with any clothes and all of them make for great photography.

There's a whole range of styles of nude. Think of the calm innocence of mother-and-baby shoots, or the raunchy eroticism of morning-after bridal sessions. There are even ways of hinting at naughtiness without revealing anything at all. From sexy to suggestive via slinky, sultry, and saucy, nude photography is a great deal of fun.

Even hinting at nudity causes a rather interesting psychological response.

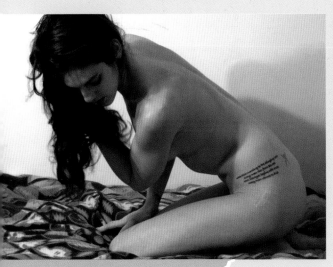

Untitled Self-portrait by Jacs Fishburne

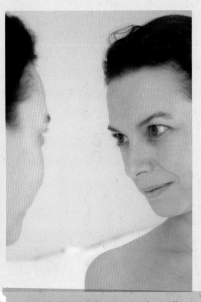

A nude shoulder and a cheeky smile is all it takes to encourage the viewer to fill in the blanks.
Photo by Daniela Bowker

If you've always wanted to give nude photography a try but don't have the confidence, either as a model or as a photographer, self-portraiture is the perfect starting point. You won't be dealing with anything you haven't seen before, and if you don't want the images to see the light of day, they don't have to.

Even better, if you're just not comfortable stripping down, I've the perfect solution.

Implied nudity

Implied nudity is just what it sounds like: photos where nudity is suggested, but the viewer can't be certain precisely how undressed the model is. There are no naughty bits on show, only a carefully constructed intimation toward their presence.

The remarkable ability of the human brain to fill in blanks and to follow paths to their natural conclusion means that even if it can't be sure that someone is naked, a suggestion of nudity will lead it to assume she or he is. Suggestion is a powerful thing that allows you to take a "nude" self-portrait without having to go any further than you feel comfortable.

What's more, less is so often more. The implication of bare skin allows the brain to drift off and to create its own imagined reality. That perfect picture in the mind's eye can be far superior to the stretch-marked, razor-burned, slightly floppy reality!

There are two ways of achieving implied nudity in photos. The first is to make someone—in this case, you—look as if you're naked when really, you're not. The other is to hint at the fact that you might, or might not be naked, but to leave the viewer guessing

So how do you go about this practically, then? It's all about cropping, lighting, and camera angles.

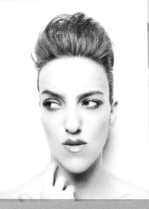

Even without any "naughty bits" on display, this photo evokes sensuality.
Photo by Sanja Peric

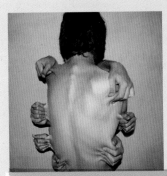

Of course, not all nudity is sensual. Some can be a reflection of the other meaning of nudity: fragility or fear.
Photo by Daniel Finnerty

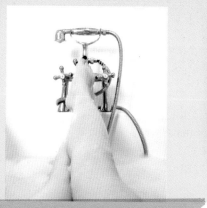

Baths are undoubtedly intimate, and the angle and treatment turn this picture into an exercise in voyeurism and titillation, rather than all-out nudity.
Photo by Daniela Bowker

Of course, if you are shy, you could go the other direction as well. Instead of hinting at nudity, you could show the nudity and hide everything else.
Photo by an anonymous contributor to this book

To start simply, and without the threat of revealing too much, wrap yourself in a towel and then shoot a head-and-shoulders portrait if you're a woman or a waist-upwards photo if you're a man. There will be lots of skin on show, and by cropping carefully to take the frame as low as it can go without revealing the towel, the suggestion of nudity. We already know that the brain will think what it wants to think, which in this case will be that you're not wearing anything at all!

Clever camera angles can also conceal as much as they reveal. If you take a shot down the length of your leg as it emerges from a steamy bath or bubbles, viewers will automatically assume that you're naked—your leg is entirely bare and you're in a bath, after all—but the bubbles won't talk.

Finally, you can use lighting to hint at what is happening in the shadows, but not divulge any secrets at all. Think of a taut tummy writhing across a bed, illuminated by a shaft of light traveling diagonally from left hip to right ribcage. What lies above and below is shrouded in darkness, but the brain loves to imagine.

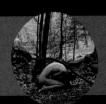

Introducing...

Jacs Fishburne

Jacs is from the Catskill Mountains of New York, 25 years old, and started taking photos in 2006. Before turning to self-portraiture, Jacs used photography to document and find a way to cope with her father's struggle with Parkinson's and dementia. Eventually, she grew to realize that she had to disengage from her camera, and re-engage with her father's last months. Jacs took the passing of her father hard, and like so many other parts of her life, her photography changed. "I fell into a deep creative rut; I felt like nothing was ever going to make me pick up a camera again. So to pull myself out of it, I started taking self-portraits, pulling one out here and there until I decided to try for a 365 project.

"I sucked at self-portraits at first. Like, really freakin' bad," she laughs. "It felt like it took me a long time to get really comfortable in front of the camera. My self-portraiture is definitely an expression of myself. It is my desire to work through my physical ailments, emotional detachments and fears, and to find comfort in myself."

The therapeutic effect of Jacs' photography may explain why so much of it tows the line between serious and funny. She says her photographs reflect whatever is on her mind that day: "I try to shoot to make sense of where I'm at in my life."

Untitled Self-portrait

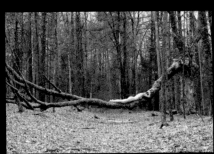

Untitled Self-portrait

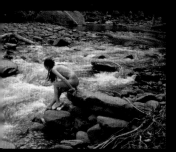

Untitled Self-portrait

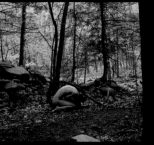

Untitled Self-portrait

Equipment used

Jacs shoots with a Canon Rebel EOS SXi. She always carries a tripod, remote (Aputure Pro-Coworker), and the lens she uses is generally a 28–90mm zoom.

"When someone is dressed in a photograph, I tend to construct a narrative regarding that person. When they're nude, allow the whole image to wash over me. I enjoy seeing the relationship of a body within a given environment. Part of this could come from the fact that my dad was a fine art painter and restorer, and nudity always seemed more natural in paintings to me than clothing.

"Unfortunately I do suffer from some pervs," Jacs explains when I ask if posting nude images of herself in a public forum ever causes any problems. "I can't control how people think or view my work. The problem is that some people, especially men, seem to think that they are paying you a compliment—they genuinely have no idea that they have crossed a line. Thankfully most people who have seen my images are really positive about it. My immediate family is a little weird about the nudity within my images, but my mom understands that it's a driving force for my healing and goes with it. I've shocked some people, including one of my managers who looked up my work because I wouldn't show it to him and spent a week awkward around me until he warmed up and got over it."

And what about the shoots themself, I wonder? Has Jacs ever been caught out? "I've lucked out shooting my nudes," she says, "but one time, I managed to find a stop pretty far off the trail. I set up my shot, stripped down, and starting shooting. About five minutes later, I turn to find a small dog wandering out of the woods, followed by a man hiking obliviously with his headphones on. I think I saw him before he saw me, but I still let out a howl and crouched down. I was pretty embarrassed. Thankfully, the guy took it pretty well and I got the rest of my shots," she says with a shrug.

* All photos by Jacs Fishburne

Untitled Self-portrait

Ooh la la!

From naughty knickers to full-frontal defrocking, these guys and gals all have a saucy side to them.

Jena Ardell

IMAGE	Undress • Knickers
AGE	28
LOCATION	Asbury, New Jersey, USA
	@jenaardell
WEBSITE	jenaardell.com

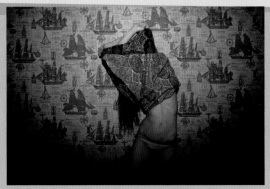

Undress

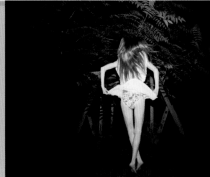

Knickers

SHOOT NOTES / MINI BIO

"When the photographer is ready to shoot, I'm ready to model—that's the beauty of self-portraiture. You can cast an impromptu photo shoot at any time of day. You're able to live on both sides of the camera.

"I tend to gravitate toward capturing borderline candid, voyeuristic moments—especially in self-portraiture. I think if done correctly, it could look just as artistic as it does sensual."

Hilary Quinn

IMAGE **Untitled**
AGE **33**
LOCATION **Cork, Ireland**
🅣 **@hqphotostudio**
WEBSITE **hqphotostudio.ie**

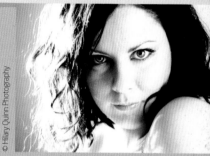

SHOOT NOTES / MINI BIO

"I suppose I started taking self-portraits to practice my photography predominantly! It's handy using yourself as a model. I used to get very nervous photographing people at the start—it doesn't bother me at all now! By photographing yourself you learn, 'Oh yeah, when I turn my head that way, and the light is coming from that direction, it looks horrific!' Or vice versa, if you light yourself exactly the right way, there you go—a really flattering portrait."

© Hilary Quinn Photography

Samantha Casey

IMAGE **Moth**
AGE **24**
LOCATION **Wells, Maine USA**
👀 **flickr.com/samanthaelizabeth**

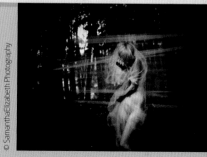

SHOOT NOTES / MINI BIO

"The day I shot this image I was harboring immense anxiety. I felt so paralyzed and wrapped in my own mental illness that I wasn't sure I would ever feel 'normal' again. I needed to release this energy and this image is how I did that.

"I did not have a timer for this image so I had to set up the material in the background, run to my camera and check my focus, hit the timer button and then run back while wrapped in fabric, stop quick and then pose! I really need to invest in a timer."

© SamanthaElizabeth Photography

Peter Wiklund

IMAGE **The Awakening**
AGE **46**
LOCATION **Hägersten, Sweden**
WEBSITE peterpinhole.com

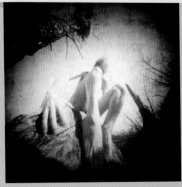

SHOOT NOTES / MINI BIO

"Giving myself the double role of photographer and model gets me more deeply involved in the final result. At the same time, it adds an extra element of chance, since I cannot see the final setup during shooting. I took this picture with my homemade pinhole camera, in an area where there had been a fire in the forest. This was one of the first rather warm days that spring—though the wind made me work fast..."

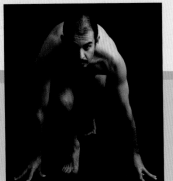

© Capasur Imagenes

Mario Granger

IMAGE **Untitled**
AGE **40**
LOCATION **Santiago, Chile**
🅣 @photogranger
WEBSITE capasur.com

SHOOT NOTES / MINI BIO

"I take self-portraits to show my feelings, emotions, and as a way to show my work."

Gary Chapman

IMAGE More Than He Bargained For
AGE 26
LOCATION Louth, UK
🇹 @garychapman
WEBSITE garychapman.co.uk

SHOOT NOTES / MINI BIO

"Here I find myself with my clothes off... But only to get a laugh! This was part of a two-part series for love/lust, this of course being lust."

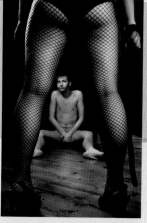

Carly Wong

IMAGE Milk, No Sugar
AGE 30
LOCATION Bristol, UK
🇹 @squidzero
WEBSITE squidzero.com

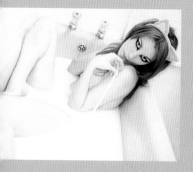

SHOOT NOTES / MINI BIO

"I was commissioned by a food magazine to create bizarre feature photographs. I enjoyed the process so much that although the commission was complete, my ideas had not been exhausted so I simply continued compiling the photo set. I did not create this image with the intention of it being used anywhere. It was more a flight of fancy, which I embarked upon with little expectation and a real sense of surprise at the result. This photo posed one of the largest threats to my camera insurance to date: my camera being suspended by its neck strap from a dainty towel rail over a bath full of milk, and my hidden hand holding my remote control for the shutter release."

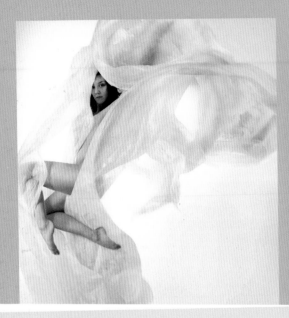

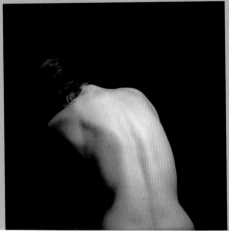

Heli
Hirvelä

IMAGE **Untitled**
AGE **28**
LOCATION **Helsinki, Finland**
WEBSITE helihirvela.com

SHOOT NOTES / MINI BIO

"I've thought a lot about taking pictures of myself. I mean, is it narcissistic or not? I really think photography is a way of exploring the world and people. I've always been a bit bothered about the fact that we can't see ourselves from the outside of ourselves. That is actually the one thing I envy about actors and other celebrities. I don't think I take self-portraits because I'm only interested in myself. I love photographing people in general, whether it's me or somebody else."

Reka Nyari

IMAGE **Untitled**
AGE **36**
LOCATION **New York, New York, USA**
🅑 @Reka Nyari
WEBSITE rekanyari.com

SHOOT NOTES/MINI BIO

"I started shooting myself when I first started taking photos in 2004. It was a form of therapy for me, self-expression, and creativity I needed to get out. I was working in nightlife in NYC and had no time to paint anymore. Through starting to shoot dark self-portraits at late hours of the night, I discovered my love for photography."

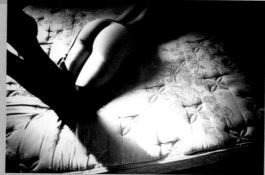

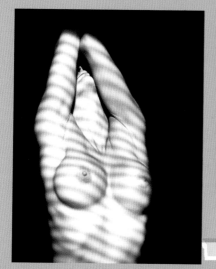

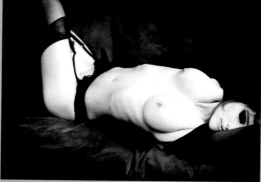

On location

In Chapter 4 we looked at how taking pictures is all about telling stories. In doing so, you might want to try shooting on location. This chapter is dedicated to shooting anywhere other than inside your home, from beaches to forests, to industrial estates. In addition to the earlier guide to shooting on location, we'll take a look at apps available on your mobile phones to help you grab better self-portraits.

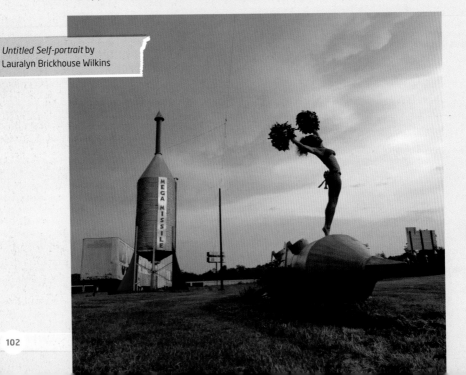

Untitled Self-portrait by Lauralyn Brickhouse Wilkins

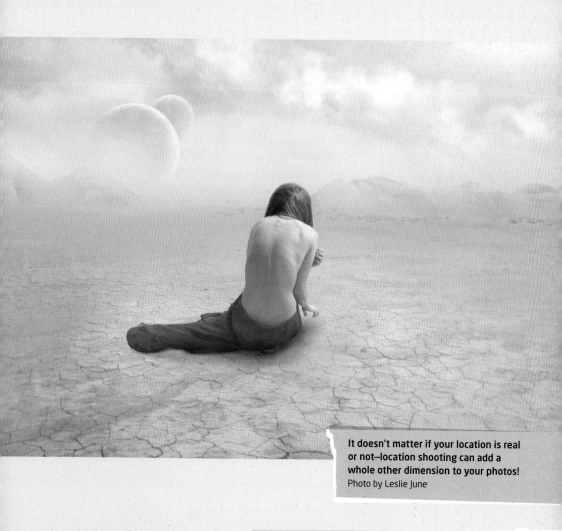

It doesn't matter if your location is real or not—location shooting can add a whole other dimension to your photos!
Photo by Leslie June

Mobile apps for better photos

Triggertrap

I am probably a bit biased when it comes to Triggertrap, because I developed it, but I really do believe it's an awesome piece of kit. Triggertrap is a universal camera trigger, which means that you can use it to trigger the camera in your smartphone, or via the magic of a dongle, your dSLR, using just about any means you can think of. There's a fairly normal Self-Timer, on which you can customize the delay every time that you take a photo. You can also trigger your camera using sound, vibration, or motion. For added fun, Triggertrap makes awesome time and distance lapses. Clap your hands and take your own portrait—how awesome is that?

Being able to trigger your camera based on a sound or a vibration is great for self-portraiture—and it saves you from having to run back and forth to your camera to set up the Self-Timer.

Snapseed

For in-phone editing, I use Snapseed. It allows me to make basic edits and there is also the ability to sharpen pictures, make selective adjustments, convert to black and white, and apply various different filters. A button allows you to compare your alterations with the original version. it is all very well being able to perform every edit under the sun on a screen a few inches across using just your fingers, but if the interface is complicated and unintuitive, you won't want to use it. Snapseed has that down, too.

As far as having a complete photo studio at your fingertips, Snapseed is my absolute favorite.

Photosynth

Photosynth is an easy means to stitch together panoramas taken using your mobile phone. While you probably aren't that interested in panoramas and self-portraits combined, Photosynth also has a desktop app that allows you to take a series of photos and then stitch them together so that they create a 3D image. Yes, that means you can shoot 3D self-portraits.

Hipstamatic

When you hear the phrase "retro photography," I bet that Hipstamatic springs to mind. Even if you don't know Hipstamatic by name, you know it by style: square photos with an old-school appearance, as if they've been taken with an antique camera and film. You select the type of film, the lens to give the look you want, and the flash effect you're going for, and combine to create a deliciously retro-looking photo.

There are lots of apps that enable you to achieve a retro look in your photos. Not all of them are tasteful, but I do think it's a great way to see your own photographs in a new light. This self-portrait of me and my sister, for example, looks an awful lot more retro after it's been through Snapseed than it did to start out with!

The benefit of Hipstamatic is that you can use it to bring a bit of excitement to an otherwise uninspired self-portrait. You can also take Hipstamatic a bit further than that. By combining it with a little dressing up, a few props, and a smidge of imagination, you have an easy means of creating a self-portrait from another time. You might not yet have been a twinkle in your parents' eyes in the 1970s, but in your photos you will look as if you lived every moment of them.

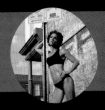

Introducing...

Lauralyn Brickhouse Wilkins

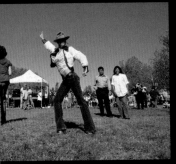

Never one not to have fun!

As a photographer, you probably have other photographers who you look up to. For me, Lauralyn is one of those photographers. In fact, writing an article about her years ago gave me the idea for this book.

Lauralyn has to take photos. She has vision and passion, and although she started from humble beginnings, it has been incredible to see her grow as a photographer over the years. When I managed to convince my publisher that doing a book on self-portraiture would be a good idea, Lauralyn was the first person I contacted.

Her life story is nothing if not dramatic. Her mother died in front of her under curious circumstances when she was three years old ("One of my earliest memories," she says), and her dad remarried a woman who turned out to be the stereotypical "evil stepmother." What followerd was a rambunctious life of joining, dropping out of, and re-joining various schools, jobs, and relationships.

One morning, many years and four children later, she woke up and realized that it had all gone wrong artistically. She decided to re-ignite her passion for photography. "A Twitter follower suggested that I contribute photographs to the weekly #HNT page—otherwise known as 'half naked Thursday.' I was opposed to the idea at first. I'd have to be crazy to put semi-naked self-pics on the internet, and risk becoming a reproachable hussy. After a brief period of deliberation, I decided that with my reputation pretty much already ruined, what could I possibly have to lose? On March 17, 2010, I staged my first official self-portrait shoot and I knew I was onto something."

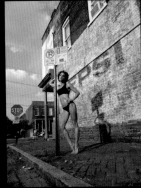

Untitled Self-portrait

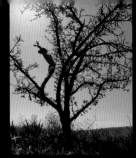

Untitled Self-portrait

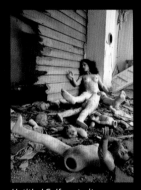

Untitled Self-portrait

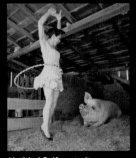

Untitled Self-portrait

"I firmly believe that self-portraiture is both a bit of an expression of myself and a projection of a different persona. On the one hand, I tend to go into my shoots with few preconceived notions about the characters that I will become—unless of course, the shoot has been specifically masterminded with a particular character in mind. Typically though, I prefer to let the atmosphere of the venue draw out the persona that I morph into in my pics. There have been times when I've reviewed a new batch of pics, and I didn't even recognize the person in them. I literally did not know how that unfamiliar person could possibly be me. It's a rather spooky feeling."

Having a prolific output of daring and progressive photography means that Lauralyn has a lot of magnificent stories to tell about her self-portraiture outings. She's been arrested four times. "I've always somehow managed to talk my way out of being charged with trespassing and/or indecent exposure," she laughs.

I had to ask Lauralyn how she aligns being a relatively high-profile self-portrait artist who often uses nudity in her work with being a parent. She has made a point of not keeping her portraiture a secret from her children. "My kids have become totally desensitized to the nudity, so there's that," she laughs. "Nowadays, they look at my self-portraits with genuine interest, and they don't mince words when it comes to critiquing them. My 13-year-old son is probably the most forthcoming with his blunt opinions." She explains that comments like, "Mom, you do that pose way too often," or "abandoned houses are getting kinda boring," keep her on her toes.

"I'm convinced that the unpolished quality of my photos enhances their snapshot-like nature, and gives them a slightly voyeuristic feel. However, I do hope to be taken seriously and respected as a capable and compelling self-portrait artist."

*All photos by Lauralyn Brickhouse Wilkins

Out & about

While the subject of self-portraiture is easy to find, the locations where you can shoot yourself are endless. These photographers have scouted out some creative spots that should get you thinking about new places to shoot.

Stephen Maycock

IMAGE **Offering**
AGE **17**
LOCATION **Warrington, UK**
🅑 @iamstephenmay
WEBSITE stephenmaycock.tumblr.com

SHOOT NOTES / MINI BIO

"I first started taking self-portraits because I was bored during the summer holidays. I know that sounds really bad and uninspired, but actually it enabled me to quickly improve in terms of finding locations, setting up a composition, and even pushing myself during editing. I would take self-portraits because the time alone let me think. I didn't need time to plan a date with a model, I was readily available and knew exactly what I wanted. When I went out to shoot this, I wasn't really planning on anything, all I knew is that I wanted to photograph myself surrounded by candles in a sacrificial and ritualistic manner. When I was riding my bike past this giant warehouse I decided to go and explore it with some friends. Instantly I knew it'd be perfect for this photo. I wanted something that really pushed the boundaries and wasn't like my other work, and I knew I had to really go for something bold."

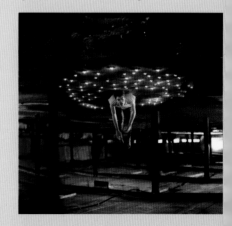

Carly Wong

IMAGE **Hunted**
AGE **30**
LOCATION **Bristol, UK**
 @squidzero
WEBSITE squidzero.com

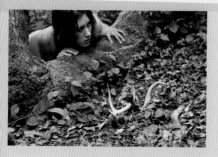

SHOOT NOTES/MINI BIO

"When I took this photo I'd been practicing creative photography for just over a year. I'd made friends with another photographer, Roxy, and together we would share ideas and take photos of each other, which was a change for both of us as up to that point we'd only been taking self-portraits. We also shared props, and she kindly lent me some deer antlers. I had this idea but didn't know whether it would work. I knew it would be difficult applying fake blood to myself and setting up all the equipment on a hilly area in the woods, plus getting the composition right. It was a frustrating process, during which a real deer appeared to watch! I was convinced that the photo wouldn't look right, but after editing I was satisfied with the result, especially as it was a departure from my usual style."

Tobias Hibbs

IMAGE **Day 147**
AGE **23**
LOCATION **Saylorsburg, Pennsylvania, USA**
 @tobiashibbs
WEBSITE tobiashibbsphotography.com

SHOOT NOTES/MINI BIO

"This photo was taken during a rainy day while at school in Turners Falls, Massachusetts. This was my favorite bridge to bike ride on and shooting at a shallow depth of field was a no brainer."

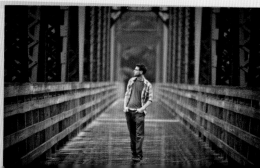

Andréia Takeuchi

IMAGE	Always Looking Up
AGE	22
LOCATION	Sáo José, Brazil
WEBSITE	andreiatakeuchi.com

SHOOT NOTES / MINI BIO

"This picture was one of the first self-portraits I took and it is still my favorite. It means a lot to me because I was going through some hard times and I decided to go out with my camera and see what came out of it. After I saw this on the computer screen, it was like I was giving myself a message of strength and hope."

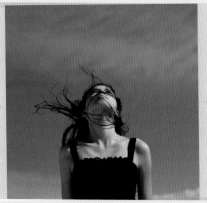

Sydney Miller

IMAGE	Offering
AGE	21
LOCATION	Ferrysburg, Michigan, USA
	@LOLSYDNEYMARIE
WEBSITE	sydneymariephoto.com

SHOOT NOTES / MINI BIO

"I had this idea of me turning around, like where you forgot to say something to the person behind you. I set up my tripod on the pier, and tried a few different ideas. I knew I wanted rich golden tones in the image, so I shot about an hour before sunset, with my camera facing toward the sun."

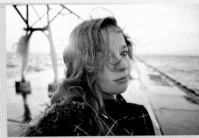

© Sydney Marie Photography

Peter Wiklund

IMAGE	Into the Light • The Great Escape The Aftermath
AGE	46
LOCATION	Hägersten, Sweden
WEBSITE	peterpinhole.com

SHOOT NOTES / MINI BIO

"Many of my self-portraits are taken in a forest that burned down about ten years ago. I also work in similar landscapes, with the common feature that they are surroundings in the gray area that exists between reality and imagination. They are real to some extent, since they are obviously photographed in the real world. But they go beyond the reproduction of nature. The landscapes would appear instead in dreams, or perhaps nightmares. Many of the images are characterized by a combination of beauty and disaster—in a somewhat romantic tradition. The final holocaust, last man standing."

The Aftermath: "This was taken on the Swedish island of Gotland, with a pinhole camera made from a black film can."

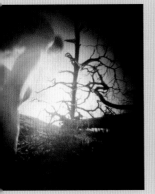

Into the Light

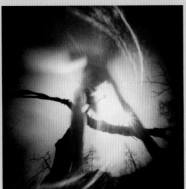

The Great Escape

The Aftermath

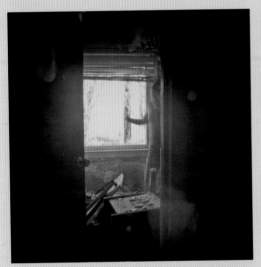

Morning Light

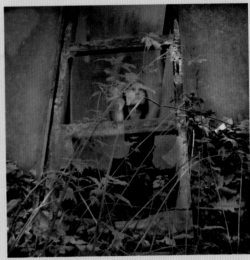

Self-portrait as a girl reaching

Melissa McCready

IMAGE Morning Light
 Self-portrait as a girl reaching
AGE 40
LOCATION Los Angeles, California, USA
 @greygaia.com
WEBSITE greygaia.com

SHOOT NOTES / MINI BIO
"I started this project after the death of my mother. I wanted to embrace the possibilities of the world around me, not mourn her death. I have always been fascinated with the abandoned and the forgotten, especially abandoned buildings. These photographs combine my search for self after losing my mother, and also explore the world of the abandoned that resides a short distance from my home."

Sigi Kolbe

IMAGE **When the tide turns**
AGE **48**
LOCATION **Windhoek, Namibia**
WEBSITE sigikolbephotography.com

SHOOT NOTES / MINI BIO

"Taking pictures of myself was inspired by the lack of having a model and as a means to further explore lighting techniques and composite work. My self-portraits have become a diary; every image transports me to what was going on in my life at the time.

"I shot the background with a long exposure at Swakopmund (Namibia), and although it looked great, I wanted it to be memorable so I used it as a backdrop. I had to mimic the correct lighting and shot myself against the setting sun in my garden. The images were combined in Photoshop. The moon was added to strengthen the composition and to form a link with the title."

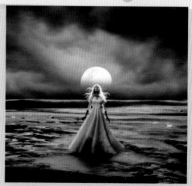

Seth Rader

IMAGE **Danger: Wildman**
AGE **20**
LOCATION **San Diego, California, USA**
@sethrader
WEBSITE sethrader.com

SHOOT NOTES / MINI BIO

"This photo was number 122 in my personal challenge to take a self-portrait every day for a year. I took it near the entrance to Mission Trails Regional Park in eastern San Diego county. At the time I was still using the kit lens, so the wide-angle distortion made it really interesting to shoot."

In action

Did you know that sharks die if they stop moving? I know a few people like that, too. Self-portraits aren't limited to photos of people standing still, and here's the best of the movers and shakers.

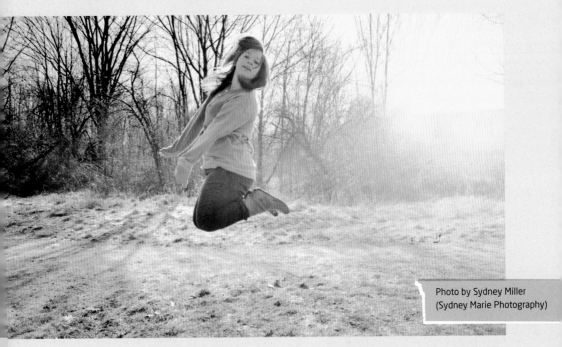

Photo by Sydney Miller
(Sydney Marie Photography)

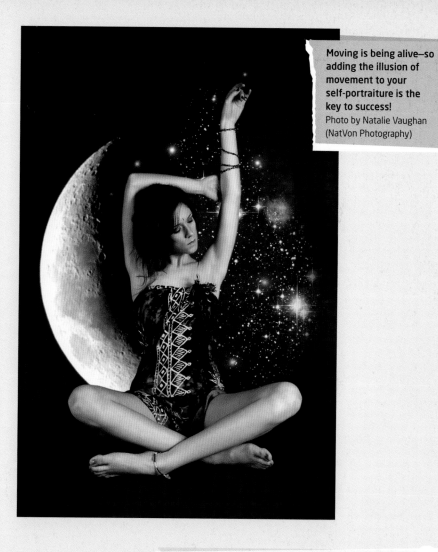

Moving is being alive—so adding the illusion of movement to your self-portraiture is the key to success!
Photo by Natalie Vaughan (NatVon Photography)

A quick primer on shutter speeds

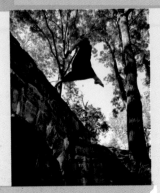

A fast shutter speed helps the model "hover in thin air" in this case.
Photo by Lauralyn Brickhouse Wilkins

A long shutter speed combined with a stroboscopic flash made this image possible.

If you're going to take photos of yourself on the move, then it's important to understand the implications of shutter speed, or how long the shutter remains open, and how varying the length of time that your sensor is exposed to light changes the appearance of your photos.

Photographs are made by exposing a camera's sensor (or its film) to light. Too much light overexposes the sensor, creating a white mass rather than an image; too little light, and the image is dark, maybe even black, and undefined.

Three factors control exposure: aperture, ISO, and shutter speed. The aperture is the gap behind the lens that lets light through to the sensor. A bigger hole means more light. ISO is the sensor's sensitivity. In lower light, increase the ISO so that it helps the sensor detect the light and create an image. Finally, there's shutter speed. The longer the shutter is open, the more light reaches the sensor.

These three factors allow you to control the exposure of the sensor. Increasing one allows you to decrease the others. If you want to use a large aperture to create a shallow depth of field, decrease the ISO and shutter speed so that the image isn't overexposed. If you're taking photos at a concert where the lights are dim, using a higher ISO should help you get better exposed photos without having to resort to huge apertures and very long shutter speeds.

This self-portrait works because of the shallow depth of field; you can't see the person all that well, but in the process, you get a powerful, emotive image.
Photo by Bryce Fields

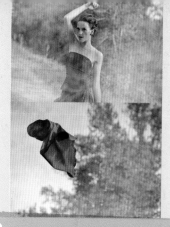

This great diptych (a combination of two photos to create one image) is a lovely example of how you can illustrate action without actually being at high speed yourself.
Photo by Sanja Peric

With shutter speed, the longer your shutter stays open, the more motion blur will show in the final image. If you think of those wonderfully evocative pictures of cities at night, showing the trails of cars' lights, they were taken using slow shutter speeds—or long exposures—to capture the sense of motion.

When you want to capture yourself in motion, you need to make a decision. Do you want to freeze the action, so that you look crisp and clear in the photo? Or do you want to look as if you're moving with streaks of blur trailing in your wake? Neither is right or wrong; it's an artistic choice. But you do need to understand the science behind it first.

Aperture and depth of field

As well as controlling how much light reaches the sensor, aperture also determines depth of field, or how much of an image is in focus and how much appears with a blurry background. A smaller aperture creates a greater depth of field, with more of the image in focus. A larger aperture, conversely, creates a shallow depth of field with not a lot in focus.

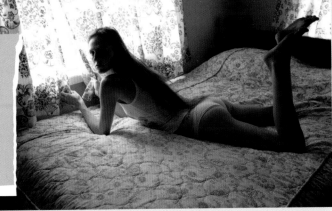

This photo looks as voyeuristic as it does because the exposure appears to be "off." It would have been easy to have a perfect exposure here, but I'm glad Jena didn't choose to do that. The light is what makes this such an intimate portrait.

Photo by Jena Ardell

Shutter speeds are usually measured in fractions of a second, so 1/100 second, or 1/8 second. On my camera, the fastest shutter speed is 1/4000 second; the longest exposure it can manage before going into "bulb" mode is 30 seconds. So where on that shutter speedometer does "slow" become "fast"? While it's very tempting to answer "How long is a piece of string," I tend to think of the tipping point between fast and slow as being when I can no longer handhold my camera because camera-shake becomes obvious. This is still the photographer's equivalent of "How long is a piece of string," because it depends on the lens I'm using, the shooting conditions, and how I feel that day. Roughly speaking, with the lenses I use most, the tipping point is between 1/50 second and 1/200 second.

Now then, how to apply these speeds to photos of you in motion? Let's imagine you running down the street and past a camera that photographs you as you speed by it. By opening the shutter for the smallest fraction of a second possible (1/4000 second on my camera), it will not have very long to capture you as you move in front of the lens. The tiniest instant, in fact, which will produce a picture that looks as if it has sliced a moment out of time and frozen it. You will look crisp, and clean, and controlled.

On the other hand, if the camera is set with a slower shutter speed (maybe 1/10 second in this instance), the sensor will be exposed for a longer period of time, and capture you moving across the frame for longer. It's a bigger slice out of time, if you like. As a consequence, you will end up with an image full of motion blur, illustrating that you're on the move. It's a bit like the little streaks that follow Road Runner as he beep-beeps away from Wylie Coyote.

To photograph a runner with their features still defined, but with evidence of motion blur around the feet, try somewhere around 1/25 second. If you extend it to 1/10 second, you'll get a pretty streaky image. By shooting with the fastest shutter speed that your other settings and the conditions will allow, you'll freeze the runner in action. These are just guides. Get out there and experiment!

So all you need to decide is if you want to look radiant in suspended animation, or if you want to look as though you're going places fast and leaving your viewers in your wake.

Apart from being a magnificently cinematic shot, this photo relies on a shallow depth of field. It is extra-awesome that this is a digital double exposure: The person standing and the person attacking are the same. Photo by John Magruder

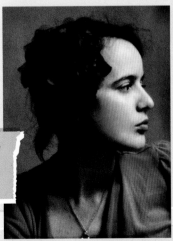

The extreme noise in this photo may have been added digitally —or it may be due to shooting at a very high ISO setting. Either way, it really adds to the retro feel of this glorious portrait. Photo by Aya Rosen

Introducing...

Sydney Miller

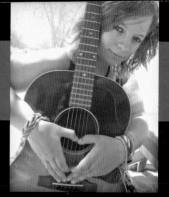

Untitled Self-portrait

In the world of self-portraiture, you often find that people spend a lot of time soul-searching and exploring who they are by showing different sides of themselves. By its nature, self-portraiture toes a fine line between introversion and showing off—and it is against this backdrop that Sydney's photography leaps out at you. It always seems so vibrantly alive, full of movement, extroversion, and abundance. So of course, I had to feature her in the book, and find out a little bit more about her.

Sydney is a 20-year-old photographer who doesn't waste any time explaining that she's into photography in a huge way. "I eat, sleep, and breathe photography," she says. She has been taking self-portraits for about four years, but made the transition to being a professional photographer about two years ago.

"I started self-portraiture in high school, more or less as an experiment of trying to mimic things I saw on Flickr. This then developed into a 365 day self-portrait project, and now when I have a crazy idea that I feel only I can pull off.

"I get these ideas from feelings I have," she shrugs, "or from things that I experience and see in the world. I try to put on the persona I see with those thoughts and feelings. But sometimes I just love to have fun in front of the camera, and keep things interesting and upbeat.

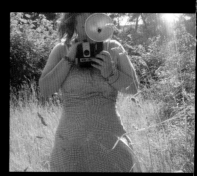

Untitled Self-portrait

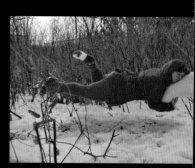

Untitled Self-portrait

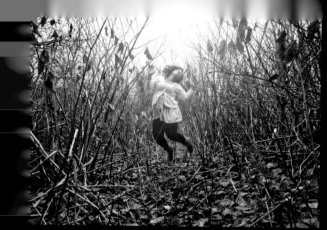

Untitled Self-portrait

Equipment used

Sydney takes photos with Nikon D200, 18–50mm, 55–200mm, and an assortment of odd lenses and attachments; including a faux holga lens and a wide-angle attachment.

"Self-portraiture is everything to me. It is the most difficult, most exhilarating and fulfilling thing. You are putting yourself out there, which for many photographers is one of the most difficult things to do. Then you add in things like jumping, or conceptual thoughts and feelings that are out of the box and are hard to get the guts to do, let alone put it in your own portfolio. It shows me who I am, not only physically but mentally, and has helped me grow as a photographer and as the woman I am today. I have become more confident in myself, and my work, and it's only up from here."

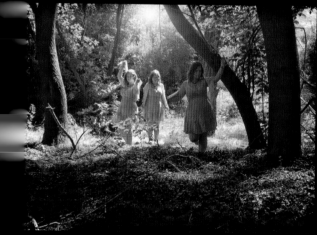

Untitled Self-portrait

* All photos by Sydney Miller
(Sydney Marie Photography)

These guys can't sit still

Running, jumping, swinging, or hovering—what kind of movement not only looks interesting, but also contributes to the meaning of your self-portrait?

Sarah Allegra

IMAGE	**In Between Awake and Asleep**
AGE	**31**
LOCATION	**Altadena, California, USA**
	@sarahallegra
WEBSITE	sarahallegra.com

SHOOT NOTES / MINI BIO

"This self-portrait deals with myalgic encephalomyelitis, addressing the feeling of constant fatigue itself, which is often accompanied by an inability to sleep once you're actually in bed. It's incredibly frustrating. You spend your entire day wishing you could just go back to bed, and once you're there, you do nothing but lie awake, very similar to people who suffer from insomnia. I often feel like I'm living in my own twilight world, neither fully awake, nor quite asleep."

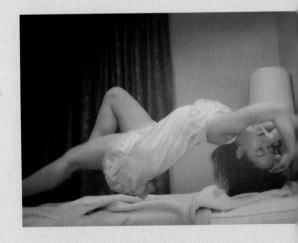

Russ Robinson

IMAGE **Zen**
AGE **39**
LOCATION **Tampa, Florida, USA**
🅑 @TampaBandPhotos
WEBSITE tampabandphotos.com

SHOOT NOTES/MINI BIO

"This photo depicts my 'floating zen' pose, and was created a few years ago as a tongue-in-cheek profile pic for social networks. It was one of my very first composites, and marked somewhat of a milestone in my photo retouching journey. Basically, I combined an image of myself sitting on a stool with a separate shot of the bare wall by itself. I then added an artificial shadow to the wall in order to complete the effect. I think it's safe to say that this photo generated lots of interesting conversation among family, friends, and fellow photographers!"

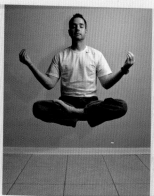

Pete Wiklund

IMAGE **Dead Man Walking**
AGE **46**
LOCATION **Hägersten, Sweden**
WEBSITE peterpinhole.com

SHOOT NOTES/MINI BIO

"I took this photograph on the Swedish island of Gotska Sandön with a pinhole camera made from a black film can."

Dana M. Bethea

IMAGE **Feet in the Air**
AGE **36**
LOCATION **Lynn Haven, Florida USA**
WEBSITE lifewellframed.com

SHOOT NOTES / MINI BIO
"I've only recently begun my semi-professional career as a photographer, shooting families, pets, and parties. I seek to capture the emotion of right now and make that moment into a lasting memory. I strive to transform objects and situations into beautiful, meaningful images. I bring to every shoot a keen understanding of composition, color, and creativity."

Monica Silva

IMAGE **Untitled**
LOCATION **Milan, Italy**
ⓑ @monicasilva2010
WEBSITE monicasilva.it

SHOOT NOTES / MINI BIO
"I started self-portraiture during a difficult period of my life, especially when I realized my body was changing. I used self-portraiture to help lift my self-confidence and to be a better person."

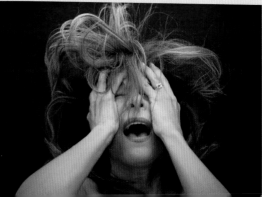

Jena Ardell

IMAGE **Midnight Ballerina • Mirabelle**
AGE **28**
LOCATION **Asbury, New Jersey, USA**
Ⓣ @jenaardell.com
WEBSITE jenaardell.com

SHOOT NOTES/MINI BIO

"I like the rush of shooting self-portraits. It's a mild adrenalin hit—equivalent to almost missing a bus. Once I set the Self-Timer, I have 12 seconds to jump in front of the camera and become another person. Instant film; instant acting."

Midnight Ballerina: "I was really pleased with this image. It took a few tries, but it was worth it. Timing is crucial when it comes to action self-portraits; it's one percent skill and 99 percent luck (sometimes)."

Mirabelle: "This shot reminds me of a self-portrait Mirabelle Buttersfield (Claire Danes' character in the film *Shopgirl*) would shoot. That is one of my favorite movies. When she shot her self-portraits, I would think 'Oh my goodness, that is me!' I could certainly relate to her character."

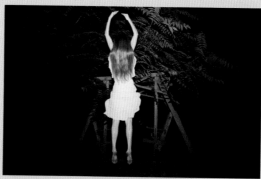

Midnight Ballerina

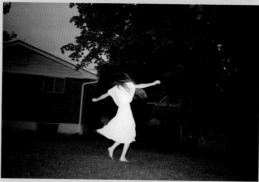

Mirabelle

Gadgets, props, & things, oh my!

You didn't think this was going to be all about people, did you? Of course not—people have been posing with props since some clever person invented the paint brush. This chapter takes us on a tour of some of the most eye-catching props, and shows you some of the useful gadgets and gizmos available to help you keep your camera stable, level, and taking photos of you!

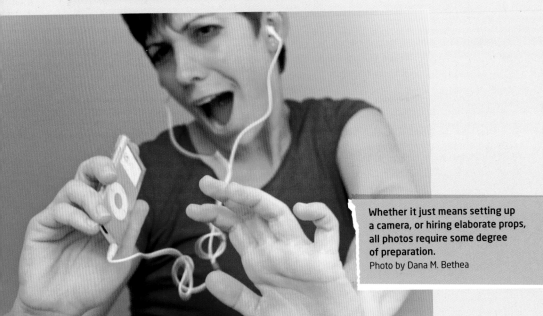

Whether it just means setting up a camera, or hiring elaborate props, all photos require some degree of preparation.
Photo by Dana M. Bethea

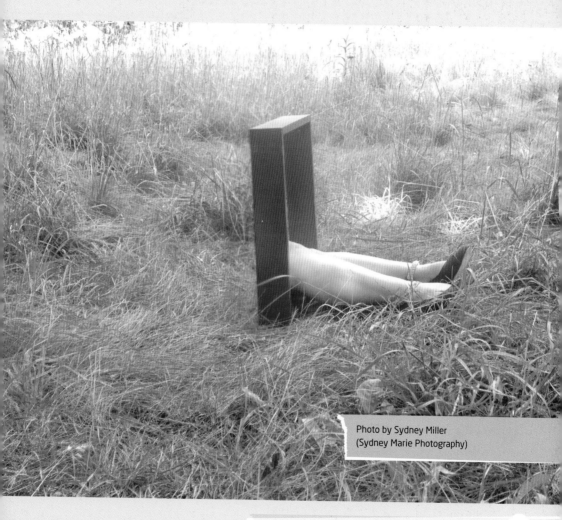

Photo by Sydney Miller
(Sydney Marie Photography)

Getting your camera stable, even halfway up a tree

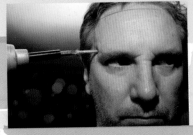

Unless you're planning on handholding your camera, you need to secure your equipment.

Self-portraits are a lot easier if the camera angles are repeatable—and that usually means using a tripod.
Photo by John Magruder

Tripod

Tripods are the traditional means of stabilizing your camera. They are made from aluminum or carbon-fiber, are lightweight/small or heavier/studier, and with ball-heads or pan-heads. A tripod should be on your photographic inventory. Tripods, however, aren't perfect. Even travel versions are sizeable and hardly suitable for packing on a whim. They can be unwieldy and impractical if you're trying to shoot in a confined space.

The Gorillapod is fantastic for all kinds of unexpected terrain.
Courtesy of Joby.com

Gorillapod

The Gorillapod is a flexible tripod-type device. They come in various sizes, suitable for point-and-shoot, EVIL, or dSLR cameras, and are small and lightweight, making them easy to throw in a bag. it is their extreme flexibility that makes them a must for self-portraits. Gorillapods allow you to do things like climb trees and take photos of yourself through leaves as you secure your camera to a branch. They give you the option to position your camera in places that a tripod couldn't manage by wrapping around railings or getting close to the ground in a confined space. Gorillapods are also more secure on difficult terrain.

Beanbags

Beanbags are zippable pockets that you can fill with rice to act as highly portable camera stabilization devices. They're great if you want to shoot from a flat surface and need to angle your camera, especially if you want to avoid a vast expanse of wood or carpet in the foreground. They're also great for stabilizing your camera and regulating its angle on an uneven surface. Beanbags are the travelling photographer's friend. You can empty out the filling before you travel so that they weigh virtually nothing, and refill them on arrival. Brilliant!

Don't forget that when it comes to "tripods," it's always possible to ask a friend to step in and act as tripod and remote shutter.
Photo by Whitney S. Williams

Tiltpods

I first heard about tiltpods when I read a review that dubbed them "more like gastropods than tripods." The description is apt: they're one-footed stabilization devices for compact cameras or iPhones. Tiltpods come as two parts. First, there's the base, which is lightweight, magnetic, and set with a small socket. Second, there is a magnetic ball joint that either screws into the tripod mount of your compact camera or has a slot for your iPhone 4 or 4S. The ball sits in the socket, rotates, and is held by the wonder of magnetism.

A tiltpod is a keychain-sized device that can help you hold your camera still. Not as stable as some other solutions, but its power comes with its portability!
Photo courtesy of Gomite

The nifty design means that you're unlikely to detach it from your point-and-shoot. The iPhone version attaches to your key ring. Without extendible legs you're restricted to balancing them on flatish surfaces, but still, for self-portraits on the fly, you could do a lot worse!

Introducing...

Richard Terborg

I've been following Richard on Flickr for a long time, and his photography never ceases to surprise me. He has an absolutely fantastic capacity for coming up with photos where he adopts a completely different persona. I've always wondered where he gets his inspiration, and he was the person who sparked the idea of doing these interviews with my favorite self-portrait photographers in this book.

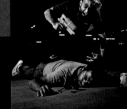

Untitled Self-portrait

Richard is from Curaçao in the Caribbean. When he finished high school at 17, he decided he wanted to travel to the Netherlands to study IT. Before he left the island, he started documenting everything that was going on.

"Digital cameras where just getting cheaper," he says, "A couple of friends pitched in and we got one."

And that, as they say, was that. Throughout his IT career, Richard never stopped taking photos, continuing to document the world around him—partially for fun, and in part to keep his parents in the loop. "I was really far away from home and would send pictures to my parents, to let them know I was still doing good."

Richard always wanted a digital SLR camera, but as a student he couldn't free up the funds to buy one—until the Canon EOS 450d came out. When it did, the older 400d model became more affordable. "I bought one, opened a Flickr account and fell in love with what people were doing," he says.

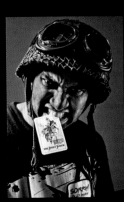

Untitled Self-portrait

Self-portraiture became a natural choice for Richard. "You couldn't have a better model," he laughs. "There is no time scheduling, which is great. What I hadn't expected, however, is that taking photos of myself also helped teach me how to pose models, and how to pull expressions.

"I'm kind of a crazy, jolly guy, or so my friends tell me," Richard laughs. "Most of my selfies are an expression of that. Something crazy, with a

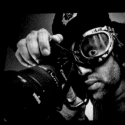

Untitled Self-portrait

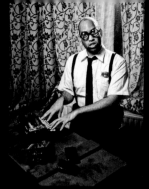

Untitled Self-portrait

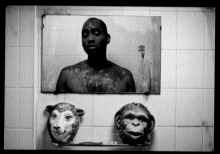

Untitled Self-portrait

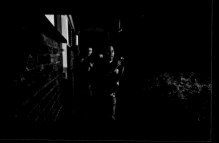

Untitled Self-portrait

Equipment used
*Richard shoots with a 7D, a Sigma 50mm f1.4
and a Sigma 10–20mm f4.5–5.6, along with
a Canon 28mm f1.8 and a Canon 85mm f1.8.*

crazier expression. And sometimes I'm an actor in a scene playing someone else."

Richard draws his inspiration from everywhere, and doesn't understand people who disconnect themselves from the world on purpose. "Nowadays, you often see people who travel with earphones in, not paying attention to the world. I would never do that. Whenever I'm on the train, traveling, I'm making sure to get the full experience. I listen, I look, I feel. That's what inspires me—you can listen to what other people are doing and try to use that as a springboard for further creativity."

Unsurprisingly for someone who spends so much time observing, feeling and being in touch with the world around him, Richard doesn't have a lot of patience for talkers. "I hear a lot of photographers who have a lot of great ideas, but then never act on them. Stop talking and start doing! They always have excuses like the weather's not right, or I haven't formulated the idea properly. Rubbish. Of course you can. Just start doing it. In fact, it was bad weather that caused me to start exploring my own house, and I found a hundred different shooting locations, just around the house. Stick some newspapers to the wall and you have a new background—the possibilities are limitless. All you need to do is to let the world inspire you."

*All photos by Richard Terborg

A horse! A horse! My photo needs a horse!

Sometimes your "horse" will be an essential bit of equipment for which you had to plan ahead, other times it will be a random object, whimsically added at the last second.

Tobias Hibbs

IMAGE **Day 70 • Day 365**
AGE **23**
LOCATION **Saylorsburg, Pennsylvania, USA**
@tobiashibbs
WEBSITE **tobiashibbsphotography.com**

SHOOT NOTES/MINI BIO

"I started a 365 project with friends. It was enjoyable to see everyone's work every day and get new ideas from each other. What I enjoyed about the process was being able to put time aside every day for this one project. There were definitely long, stressful days where taking one more picture was the last thing I wanted to do, but in the end I never missed a day and I'm grateful that I didn't."

Day 70: "I got this idea from an image of one of my favorite bands, Thrice, and tried to recreate part of it. This was photographed while I was in school using a beauty dish and I was holding dirt, with rubber cement on it."

Day 365: "This was the final image. I printed out every day and put them in a spiral so all of the images are in the correct order. This image was very important because it was the final chapter of the biggest personal project I have done, and it felt so good to have a piece like this to top everything off."

Day 70

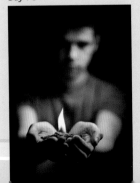

Day 365

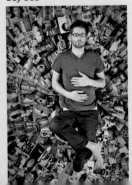

Gadgets, props, & things, oh my!

Rosa Gonzalez

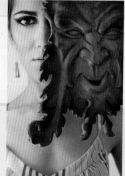

IMAGE **Concealed Identity**
AGE **28**
LOCATION **Canton, Georgia, USA**
 @rosacreative
WEBSITE rosacreative.com

SHOOT NOTES / MINI BIO

"My father carved the mask in this picture decades ago. I thought it'd be the perfect prop for a selfie. I dabble in make-up artistry and find it to be another creative outlet. With mask in hand and make-up on face, I took this image. I think it plays well on the Jekyll and Hyde theme. I also think the quote from *The Scarlet Letter* is apropos: 'No man for any considerable period can wear one face to himself and another to the multitude, without finally getting bewildered as to which may be the true.'"

Wallei Bautista Trinidad

IMAGE **Untitled**
AGE **34**
LOCATION **Ajman, United Arab Emirates**
 @wallei
WEBSITE facebook.com/walitografia

SHOOT NOTES / MINI BIO

"I am a dreamer and a lover and my journey won't be completed without capturing the memories I am afraid to forget. I take photos to pay attention to and celebrate my life—the large and the small. I photograph to remind myself that I am part of something much bigger than my little corner of the universe. I have no particular style, but I ensure that my images speak of something, tell stories and project emotion. Self-portrait is a portrayal of moods and most transparent evidence of who you are. I find taking photo of myself as therapeutic and it elevates my mood."

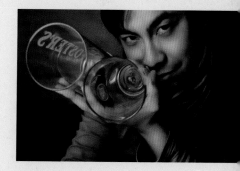

A horse! A horse! My photo needs a horse!

Elly Lucas

IMAGE **Violin 1**
AGE **22**
LOCATION **Sheffield, UK**
🅣 @ellylucas
WEBSITE ellylucas.co.uk

SHOOT NOTES / MINI BIO

"Despite its major role in my life, one summer morning I woke up realizing that I'd hardly depicted my relationship with music in any of my personal photographic work. I'd photographed so many other musicians that it just hadn't occurred to me to portray myself in the same way. The sage flowers in the garden were in full bloom and the slightly overcast weather lent a lovely soft light to the set up, so I couldn't quite resist taking a snap or two."

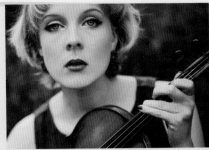

Sarah Allegra

IMAGE **Exoskeletonation**
AGE **31**
LOCATION **Altadena, California, USA**
🅣 @sarahallegra
WEBSITE sarahallegra.com

SHOOT NOTES / MINI BIO

"I created this self-portrait to help deal with some of the effects of living with myalgic encephalomyelitis, or ME. The exact cause and nature of the disease is still unknown, but one theory would classify it as an autoimmune disorder, similar to lupus and MS. I played with the idea of an autoimmune disease for this photo; my body is throwing up defenses, which actually only hurt and hinder me more. I wanted this photo to have a feeling of sadness, strength, beauty, and frailty."

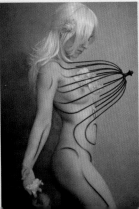

Gadgets, props, & things, oh my!

Simon Withyman

IMAGE **Untitled • Milk • Flour**
AGE **29**
LOCATION **Bristol, UK**
WEBSITE simonwithyman.com

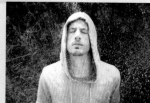

Untitled

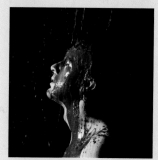

Milk

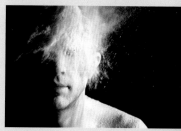

Flour

SHOOT NOTES/MINI BIO

"Half the things that I have done with self-portraiture I've done because I'm not sure a model would want to do them, for example, repeatedly having flour thrown at their eyes..."

Untitled: "This was the first self-portrait I ever attempted. It was tricky as I was not used to setting up a tripod and deciding where to point the camera without a model. I wanted to hold a reflector to illuminate my face and sprinkle flour to make it look as if it was snowing. We had to get the focusing right, the correct shutter speed for the movement of the flour, sprinkle the flour and press the remote control all at the right time (plus it was threatening to rain, which meant the light kept changing). In the end we didn't try this for too long, but I was relatively content with the outcome and it inspired me to be more inventive and try new things."

Milk: "This was the second self-portrait that I attempted, something much bigger and bolder: food coloring mixed in with milk and poured all over me, in the middle of a field in the summer. I ended up with evil horsefly bites and not much success on the photo front. When I edited these images I knew deep down that something didn't quite fit. That's when I realized that this could have worked much better with a studio flash. Several days later I attempted this shoot again. This final shot was from the second set and I was much more pleased with this attempt."

Flour: "The difficulty here lay in the timing. It was tricky to get a shot that was not one of two failures: a ball of flour flying close to my face, or a white face and bits of flour falling off after the impact. What I wanted was the exact point of impact to give the impression of an exploding head. I often favor the surreal, so this turned out to be my favorite self-portrait."

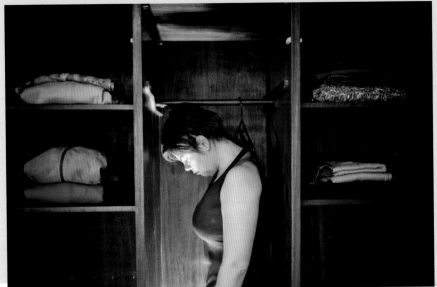

Elis Alves

IMAGE **Untitled**
AGE **37**
LOCATION **Curitiba, Brazil**
WEBSITE elisalves.com

SHOOT NOTES/MINI BIO

"In 2011 I started a 365 self-portrait project. I learned so much during this process it's hard to put it all into writing. As the project went on I grew to love more conceptual work. I'm sure it also influenced my photojournalism work with my clients. This shot was taken quite early on my 365. I don't like to title my images because I'd rather leave the interpretation open to the viewer. This shot happened because we were tearing down an old wardrobe and the idea came to me of 'different skins' we could put on or off, just like clothes. Colors, framing/balance and light were really important so I made sure I had good color clothes on both sides and enough light so that the viewer's eye would go straight to me first when looking at the photograph."

Alex Minkin

IMAGE **Untitled**
AGE **27**
LOCATION **New York, New York, USA**
🅣 **@alexminkin**
WEBSITE alexminkin.com

SHOOT NOTES / MINI BIO

"I typically take self-portraits on impulse to try out new equipment, or when I get what I think is a clever idea. This one was for school, and I wanted to reflect part of my background that otherwise isn't obvious. The stereotype is a chance for me to act in front of the camera and play around with being a small portion of a personality."

Monica Silva

IMAGE **My Hidden World**
LOCATION **Milan, Italy**
🅣 **@monicasilva2010**
WEBSITE monicasilva.it

SHOOT NOTES / MINI BIO

In this portrait, Monica plays the role of a mother but in the meantime a little girl with her doll, as she really experienced that feeling when she became a mother of her son, Davis. There is much more to be read in this image, a story to be unfolded.

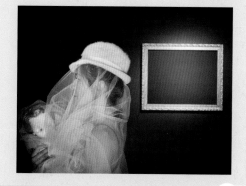

I'm seeing double!

Reproducing yourself several times over in the same image feels as if it's the ultimate piece of camera trickery. Not only are you photographing yourself, but there are multiple versions of you!

Multiplicity, or the art of creating images containing several yous, isn't just a digital discovery. It's something that people have been doing for decades and in fact is remarkably easy to achieve with film. You set up your shot, and either don't wind your film before re-exposing the frame with you positioned anew in the scene, or you wind your film and then wind it back again in between shots. The important thing is to underexpose all of your shots to ensure that your final image isn't one huge, overexposed, white mass!

Using digital trickery to add yourself to your own image more than once is a great way to add an additional dimension to your self-portraits.
Photo by Jeff Maynard

Of course, double exposures are as old as photography itself (go on, Google it!). On most digital cameras, however, the only way to get a "double exposure" in-camera is to use a long exposure and then trigger a flash more than once.
Photo by Daniel Finnerty

By using an image-editing package, you can create photos of you playing with yourself. Wait, no, that came out wrong.
Photo by Dale Moore

Think outside the box to create the most eye-catching photos.
Photo by Natalie Vaughan
(NatVon Photography)

I'm guessing that you would probably prefer a digital option for creating multiplicitous images. In fact, you don't have just one digital option, but two. Increasingly, digital cameras are being manufactured with a multiple-exposure setting. This allows you to re-expose the same "frame" in-camera and helps you to adjust your exposure accordingly to help prevent under- or (more likely) overexposure. If, however, you don't have one of these all-singing, all-dancing marvels, it's time to make friends with Photoshop.

Before we go any further, it's important to remind you that achieving a great final image relies on producing a good image in-camera first. It doesn't matter how ginormous the barrage of editing you're going to subject your photo to, it's got to be good from the get-go. This is the same for a multiplicity image as any other.

Your starting point for a multiple exposure is your concept. You need to plan out what you are attempting to convey, and where you want to appear in the final image. Don't forget, you can't move things like furniture in between shots!

Creating a multi-layered photo

Next comes the setup. As you are going to be layering your images one on top of another, the composition and lighting need to be identical in each shot. Set your camera on a tripod, ideally with a wide-angle lens (or at least one that takes in your entire scene), and a relatively small aperture to get everything in focus.

For maximum flexibility, shoot a "plate" image, or a shot of the scene without any characters in it, to use as your base. Shoot yourself in as many different positions as your composition demands. It's a good idea to go for more rather than fewer, so that you have plenty of options when it comes to compositing.

For the purposes of this chapter, I'm using a few photos donated by Daniela Bowker. In Photoshop, import your images using the Load Files in Stacks option (File>Scripts>Load Files in Stack), which should import your images so that they are perfectly layered one on top of the other. Next apply a layer mask to each of the layers, barring the background image, which should be the "empty" plate.

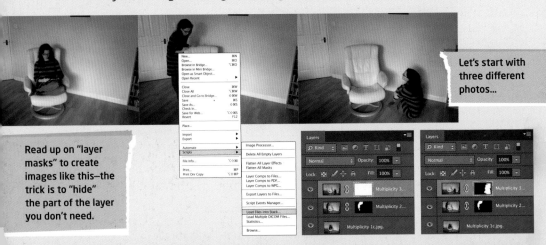

Let's start with three different photos...

Read up on "layer masks" to create images like this—the trick is to "hide" the part of the layer you don't need.

You don't need an awful lot of precision, but be extra careful in the areas near where you are overlapping with yourself—this is where the "realism" of the images becomes endangered if you get it wrong.

Using the eye icon on the Layers Palette, toggle off all of the layers from view except Layer 1. Brush yourself out of your image. Be sure to include anything that will add to the realism, for example, the indentations in the chair, or shadows you cast. It's about making the unbelievable believable, and these details will help.

When you've disappeared from the scene and you're happy with the refinement of the edges, invert your selection by pressing Cmd+I on a Mac or Ctrl+I on a Windows machine. You will miraculously reappear and the superfluous background will disappear.

Repeat this process for each of the layers, toggling them on and off to decide which versions you want to keep, and which you wish to discard. I'd recommend saving the image as a PSD file with all the layers intact, which will allow you to revisit it and re-edit.

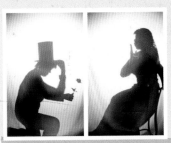

Get creative—this is meant to be fun, after all!
Photo by Elis Alves
(Elis Alves Photography)

When you've hit on the combination that works for you, you can delete the layers with the extraneous yous, and then save the image again as a PSD file before flattening it and exporting it as a JPEG.

There you go, one multiplicitous self-portrait of you!

Introducing...

Jessie Redmond

Jessie is an incredibly talented photographer who seems to have fully embraced the multi-exposure style of photography. But instead of using it as a gimmick (which, unfortunately, is too easy), she's found a tremendous way of implementing the technique into her photographic work in a natural-looking, expressive kind of way.

A relative newcomer to self-portraiture, Jessie started shooting herself in 2009. "I had recently decided to teach myself digital photography and was quite limited when it came to post-production; I wanted to explore the boundless possibilities that it had to offer. Self-portraiture was not only convenient, seeing how I would always be ready and available, but it also was a great way to challenge myself," she says. It's perfect for control freaks, too, of course, as it enables photographers to be in control of every part of the process: concept, preparation, modeling, shooting, and post-production.

"It was not until my first day in the darkroom when I developed my first print that my passion began to unfold." She says fondly, "while gently rocking the developer tray, I watched my image come to life and found a new love."

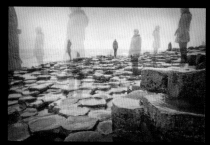

Lightkeeper

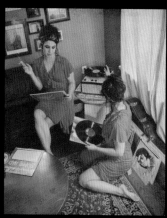

Bored Housewives

"I definitely rely on my camera during times of struggle and use self-portraiture as an outlet," Jessie says, and explains how she uses her photographs as a diary of therapeutic self-expression. "On the other hand," she reflects, "self-portraiture can be a playful escape from reality, where you get to bend the rules and become whomever or whatever you choose to be.

"I find inspiration everywhere: discovering a new location, a vivid dream, finding a great prop or article of clothing, surfing the web, and viewing other artists' work.

"It was after admiring the work of Natalie Dybisz," Jessie says, referring to the artist who is better known as "Miss Aniela" to her fans (check out her work at MissAniela.com), "that I decided to experiment with multiplicity images. I have always been drawn to her work. I particularly respect her for her ability to represent herself in a different light, while focusing on composition and maintaining a playful quirkiness to her imagery.

"Keep shooting!" she offers to other photographers. "Self-portraiture can be very rewarding, but also very frustrating at times. Being in control of every aspect of the shoot has its ups and downs. There have been many occasions where an idea did not turn out the way I envisioned. At times I roll with it and end up with a new image altogether, but other times I end up with nothing. Try not to let this get the best of you, and shoot like nobody's watching!"

Equipment used

Jessie is a Nikon girl, and shoots a D700. On the glass side, she mostly switches between a 24–70mm f2.8 and a 50mm f1.8.

The Gates of Eden

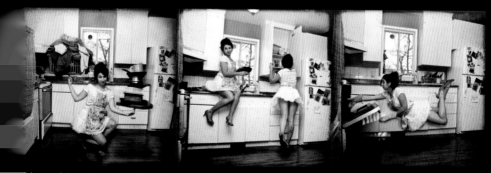

This set of three images is entitled *Magnificent Mademoiselle*

* All photos by Jessie Redmond

Me, myself, & I

Mirrors, double exposure, or Photoshop work—you'll see there are quite a few ways to show up in your self-portrait more than once.

Jessie Redmond

IMAGE	Focus • Untitled • Scattered
AGE	30
LOCATION	Edmonton, Alberta, Canada
WEBSITE	jredmondphotography.com

SHOOT NOTES / MINI BIO

Focus: "This photo is a reflection of me feeling in limbo. I felt that I was tuning in and out of focus of knowing whom I was and where I was headed in life."

Untitled: "I wanted to play with the relationship between the viewer and the subject matter, drawing the observer into a confrontation with one of the clones while sustaining an awareness of the others. It is a representation of social interactions: The clones represent different aspects of an individual that are always present, yet the observer is drawn into one particularization of that person."

Scattered: "This image represents feeling beside myself, scattered and all over the place. I was burdened with decisions on how to move forward in my life and divided between my new home in Alberta and the place I grew up in Nova Scotia. I felt a struggle as an artist attempting to build a career while still maintaining elements of the passion that drew me to photography in the first place."

Focus

Untitled

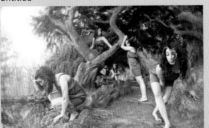

Scattered

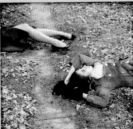

Bryce Fields

IMAGE **Can You See the Real Me**
AGE **49**
LOCATION **Salem, Oregon, USA**
🇹 @bdf2
WEBSITE flickr.com/photos/redlantern/

SHOOT NOTES/MINI BIO
"My self-portraiture started as part of a Flickr group I belonged to called Utata. They held biweekly photo projects called 'Iron Photographer' where they would specify three elements that had to be in the photo. It was up to the photographer how to work those three elements in as creatively as possible. I pretty much only had me and my wife as models, so..."

Melissa Maples

IMAGE **Eight is Enough**
AGE **40**
LOCATION **Anatalya, Turkey**
🇹 @melissamaples
WEBSITE melissamaples.com

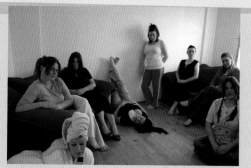

SHOOT NOTES/MINI BIO
"On 8.8.8 (2008-08-08) I noticed various people creating photos on the theme of the number eight, so I decided to join in. All eight of these girls are me; the thought of there being eight different versions of me frightened a few people."

Dale Moore

IMAGE **Untitled**
AGE **21**
LOCATION **Kannapolis, North Carolina, USA**
WEBSITE dmphotography.com.nu

SHOOT NOTES / MINI BIO

"I love all photography styles, but one of my favorites is definitely photographing people—including myself. You can really get to know somebody by taking a photo of them and I was surprised how much I learned about myself while shooting my own self-portraits. I plan to take my camera to the grave with me. Who knows maybe I will even get some shots of the afterlife."

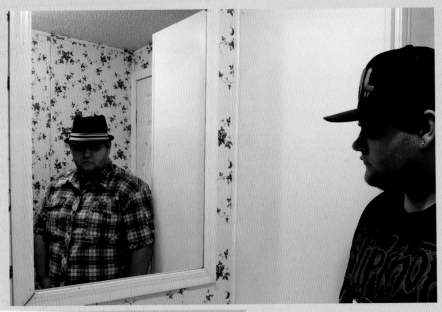

I'm seeing double!

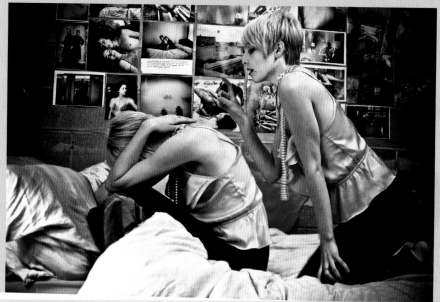

© SamanthaElizabeth Photography

Samantha Casey

IMAGE **Nothing to Fear but Myself**
AGE **24**
LOCATION **Wells, Maine, USA**
WEBSITE flickr.com/samanthaelizabeth

SHOOT NOTES / MINI BIO

"This photo was taken in the midst of my anxiety and depression. I felt controlled by another version of myself. I had lost the majority of my confidence and I used this image to convey that to the people that could not understand my verbal descriptions of how I felt. This was a time when my art was not only my passion, but my voice. I used the ten-second timer feature on my camera for this shot. I put a stuffed animal on my bed where I thought I would be lying, focused it, ran and lay down, then checked the image. Then ran back again for the second version of myself."

Me, myself, & I **147**

Toy cameras galore

There's something very primal and "real" about lo-fi photos.
Photo by Daniel Finnerty

If you hang around anywhere that photos are shared on the internet, you cannot fail to notice the plethora of pictures that have peculiar color casts, odd light leaks, and look as if they were taken 35 years ago, despite very obviously being snapped last week. The chances are, they've been taken with a toy camera.

As the name suggests, toy cameras produce images that look as if they have been taken with a cheap plastic lens, a body that leaks more light than a sieve drains water, a light meter that can scarcely differentiate day from night, and then the film is processed in the wrong chemicals. It's all very... distorted.

While the debate rages among photographers about the validity of photos taken with cameras that are more an exercise in luck rather than photographic judgment, there's one inescapable fact when it comes to toy cameras: they are a tremendous amount of fun. Nail your composition, release the shutter, and wait to see what happens.

This picture was tack-sharp when I started off, but even after extensive editing, I couldn't make it work as a "lo-fi," toy-camera style shot. It was only after I artificially blurred the photo that it finally came together!

Digital Lomography

Lomography is a term synonymous with the recent, rather hip toy camera movement. Lomos—cheap Russian cameras with plastic lenses—were the cameras that started the craze. There are, however, a heap of different toy cameras out there. Behind Lomos, you're most likely to have heard of Dianas and Holgas, which have been manufactured for years.

However, if you don't own a toy camera and can't quite bring yourself to splash some cash on one, all is not lost. Select a self-portrait, open up your editing suite of choice, and let loose with the split toning and graduated filters. Digital Lomography is at your fingertips!

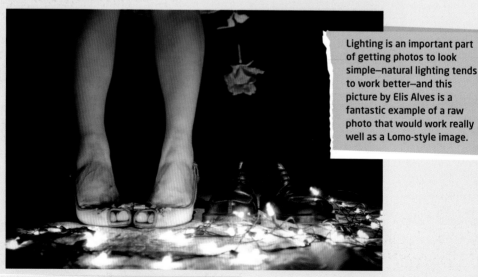

Lighting is an important part of getting photos to look simple—natural lighting tends to work better—and this picture by Elis Alves is a fantastic example of a raw photo that would work really well as a Lomo-style image.

I was gutted to find that this picture was out of focus when I first saw it—I was foiled by the autofocus on this occasion—but there was something about my expression and the lighting that made me try a round of editing on the photo anyway. Despite being grossly out of focus, I love the retro feel in this shot.

Before you start playing with the tonal curves and adding vignettes to your photos, it's useful to know what to look for in a toy camera-esque image.

First, the exposure. The light meters in toy cameras tend to be horribly calibrated, meaning that images are badly exposed.

Next come the light leaks. The sealing on toy cameras is verging on the non-existent, so images come out with huge streaks of light smeared across them.

As the lenses are cheap and plastic-y, you can expect odd aberrations and a touch of vignetting in your pictures.

Finally, although the camera itself won't cross-process your film in the wrong chemicals to produce weird color casts, it does seem to be the trendy thing to do.

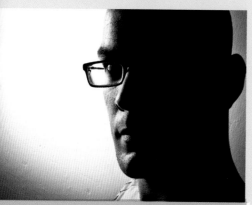

This photo is the result of a pretty crazy experiment: turning a photo taken with a ludicrously expensive Leica M9 into a toy-camera look shot.

Daniela Bowker (you might recognize her from Chapter 3) has very kindly turned over one of her practically perfectly-lit self-portraits and given it a toy camera makeover. It's worth noting that she hasn't pushed things quite as far as she could as she prefers a touch of subtlety.

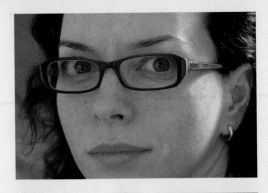

A fairly ordinary-looking self-portrait that Daniela took of herself when she was getting used to wearing glasses.

She's ramped up the exposure, added depth to the blacks, and gone, overboard on the brightness and the contrast. It looks cartoon-like, doesn't it?

To give the picture the requisite mushiness of a cheap plastic lens, the clarity slider has been nudged to the left.

To add the light leak, she used one graduated filter to the left of her ear, and another to the right, the settings roughly opposite for each, to create a yellow smear.

Although the cross-processed effect might be the last on the Spotters-Guide-to-Lomography list, it's best to fiddle with it now. So head to the split-toning function and play around. You can spend hours adjusting the levels here, until you reach the look that you want, with more emphasis on the reds and purples or the greens and yellows.

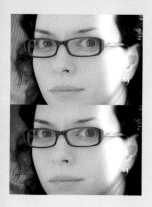

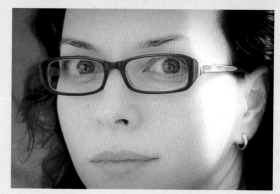

Not completely happy with this yellow-green look, she tried a more pinky-red version.

As this is a toy camera-type image, Daniela hasn't worried about sharpening her photo, but she has added a vignette. Not too much though. Again, it's meant to be subtle, not knock-you-over-the head with a plastic picture-taking device.

Finally, she added a hint of grain to help recreate the film feel of a toy camera. Et voila—from studio self-portrait to tricksy toy-camera creation.

Of course, if that all feels a little too complicated, you can always press the Cross Process or Toy Camera preset that your editing suite is bound to include. But where's the fun in that?

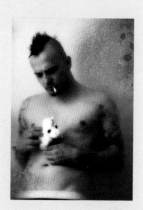

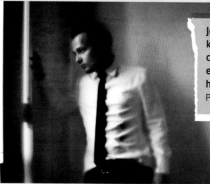

Jeff Maynard is the king of getting a "toy camera" feel to work extremely well with his photographs.
Photos by Jeff Maynard

Messing around with my Holga

So, what happens when you let a large number of snap-happy self-portraiture artists loose on their own images and turn them into toy camera shots? Let's take a look...

Naomi M Hipps

IMAGE **Dark Side**
AGE **18**
LOCATION **Prestwich, UK**
WEBSITE flickr.com/photos/naomihipps/

SHOOT NOTES / MINI BIO

"This was taken to show off my new nose piercing. It shows how I can still be soft and innocent even if in some people's eyes the piercing is a symbol of rebellion and casts a dark shadow over my appearance. I think the eye contact is what makes this shot connect.

"This was taken in my front room as the natural light poured in from a window onto my non-pierced side. I held a camera and pointed it at myself for this shot. The focus is on the piercing; some people argue it should be on the eyes, but for me this was about the nose piercing, which is why I chose the odd focus point."

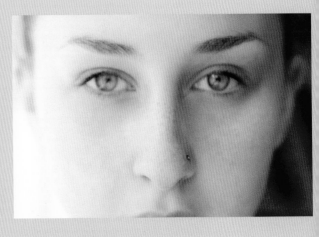

Melissa Maples

IMAGE	Untitled
AGE	40
LOCATION	Anatalya, Turkey
	@melissamaples
WEBSITE	melissamaples.com

SHOOT NOTES / MINI BIO

"I visited Iceland in March of 2003 and it changed me forever. This was a photo taken in the midst of that change; I had been experimenting with Lomo cameras at the time and the SuperSampler was one of my favorites. This was taken with E6 film and cross-processed."

Claire Streatfield

IMAGE	Pop Goes Me
AGE	31
LOCATION	Maidstone, UK
WEBSITE	furwillfly.blogspot.co.uk

SHOOT NOTES / MINI BIO

"Stick me in a wig and I immediately pull a silly face. I was going for an Andy Warhol pop-art style. I took this in my front room at home, with my bright red wall as a background. It was a bit of a balancing act with the tripod perched on the sofa, but I got there in the end. I like self-portraits that transform me into someone totally different, and I definitely achieved that with this shot."

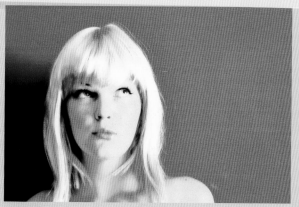

Index

Picture credits

Allegra, Sarah p63, p68, p134, p122
Alves, Elis (Elis Alves Photography) p14, p62, p69, p135, p141
Ardell, Jena p5, p82, p96, p118, p125
Aura, Good p89
Ayoub, Diana p50

Bethea, Dana M. p124, p126
Bou, Gemma p25
Bowker, Daniela p48–49, p91, p93, p140–141, p152–153
Brown, Riann p51

Casey, Samantha (SamanthaElizabeth Photography) p97, p147
Chapman, Gary p55, p99
Chea, Sodanie p35, p61

Donazzan, Marco p41

Fields, Bryce p117, p145
Finnerty, Daniel p92, p138, p148
Fishburne, Jacs p91, p94–95
Foxx, Ice p85

Gastelum, Gabriel D. p39
Gonzalez, Rosa p38, p46, p133
Granger, Mario (Capasur Imagenes) p98

Harris, Emme p21
Hayward, Mat p89
Hernandez Jr., J.G. p86
Hibbs, Tobias p109, p132
Hipps, Naomi p19, p35, p154
Hirvelä, Heli p100
Holbrook, Todd p47

June, Leslie p84, p103

Kapush, Callan p16–17
Kolbe, Sigi p113

Lucas, Elly p19, p83, p134

Maddison, Amanda p51
Manuel Ek Photo p40
Maples, Melissa p53, p74, p145, p155
Magruder, John (John Magruder Photography) p66–67, p119, p128
Maycock, Stephen p108
Maynard, Jeff p43, p138, p153
McCready, Melissa p112
Miller, Sydney (Sydney Marie Photography) p2, p47, p71, p75, p78, p110, p114, p120–121, p127
Minkin, Alex p137
Moore, Dale p69, p139, p146
Moreno, Jose Antonio p34

Dedication

For anyone who is brave enough to bare their soul by photographing themselves.

Thanks & acknowledgements

Shooting Yourself is a book I have been wanting to write for such a long time, and I am so incredibly happy that the team at Ilex were willing to let me take the idea and run with it. Special thanks go to Adam, Natalia, Frank, and Tara for helping me make it happen—and Lu-Lu, for helping with the tremendous admin task of making sure all the photos were cleared for use in the book.

An extra-huge thank you to Daniela Bowker, who was extremely diligent in helping with the research and planning of the book.

And of course, my ever-lasting gratefulness for all the incredibly talented photographers who contributed their self-portraits as examples for this book. Absolutely incredible—and thank you so much!